WINDSOR
THROUGH TIME
The Friends of Windsor &
Royal Borough Museum

AMBERLEY PUBLISHING

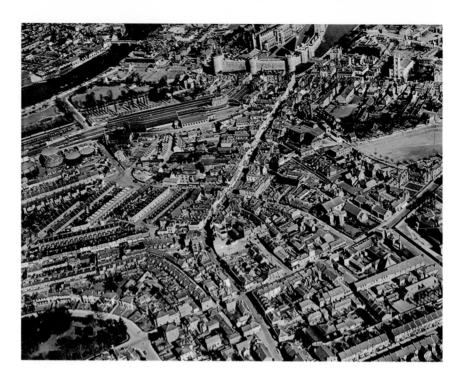

This 1938 aerial view shows the layout of the town, which had developed during Victorian times. Features easily identified are the castle, the railway viaduct, gasworks and river. In the bottom left-hand corner, the private gardens of Clarence Crscent can be seen and above is the maze of littoe streets, which were replaced in th 1960s by the Ward Royal complex of social housing. Further development followed in subsequent decades. Some of the changes are recorded in this book.

First published 2013

Amberley Publishing
The Hill, Stroud, Gloucestershire, GL5 4EP
www.amberley-books.com

Copyright © The Friends of Windsor & Royal Borough Museum, 2013

The right of The Friends of Windsor & Royal Borough Museum to be identified as the Authors of this work has been asserted in accordance with the Copyrights, Designs and Patents Act 1988.

ISBN 978 1 4456 1595 0 (print)
ISBN 978 1 4456 1604 9 (ebook)

British Library Cataloguing in Publication Data.
A catalogue record for this book is available from the British Library.

Typesetting by Amberley Publishing.
Printed in Great Britain.

Introduction

Of all the attractive small towns situated along the River Thames, Windsor is almost certainly the most well known. The magnificent castle and Royal connections attract hundreds of thousands of visitors each year, making it one of the major tourist destinations in the country. Windsor owes its existence to William the Conqueror. In 1067 he planned a ring of castles to protect London and one site chosen was a chalky outcrop by the Thames on land leased from the parish of Clewer. Around this fortification grew a new settlement. By the reign of Henry I the castle had become a Royal residence, with the King holding court there from 1110. The *Anglo Saxon Chronicle* referred to New Windsor for the first time, distinguishing it from its Saxon neighbour downstream, which declined in importance to become the village of Old Windsor.

Until the thirteenth century, New Windsor remained under the jurisdiction of the castle. As streets and houses reached northwards to the bridge and wharves, townsfolk moved into crowded tenements, some even abutting the castle walls. It became a parish in its own right, the church being consecrated in 1184, and a commercial centre developed around a triangular market place between the castle gate, the King's great garden and the church. The importance of this flourishing community was recognised by Edward I in 1277, who granted a charter, raising the status of Windsor to that of a free borough and allowing a greater degree of self government. Over the centuries the town prospered but remained small, mainly concerned with servicing the needs of the castle and its garrison.

George III's fondness for Windsor led to more extensive development during his reign and through the Regency period. Houses were built to accommodate the increasing number of workers and more substantial properties catered for the growing middle class. The soldiers were accommodated in the infantry and cavalry barracks from the nineteenth century, swelling the population further. New roads were laid out and the town expanded to the south and west.

The coming of the railways in 1849 produced major changes. Opposition by Eton College and the Crown was overcome and the two companies provided funds for clearing many of the slums, which were replaced by terraced housing. The town's two new stations made for easy access to London, transforming the small country town into a more cosmopolitan community, with a variety of housing stock, schools and churches being built. Meanwhile, visitor numbers greatly increased, encouraged by cheap excursion fares.

The Edwardian period saw concern about living conditions near the river. The First World War delayed proposals for improvement but in the 1920s River Street was cleared and the residents moved out to Dedworth. Windsor's first car park was constructed on the site in recognition of the new motor age. Local bus services were introduced to bring people into town.

By 1945, Windsor, like much of the country, was in need of refurbishment. The council's development plan of the 1950s would see many of the properties in the Goswell Road area razed and replaced by flats, with more housing out towards Dedworth. Although the plan was not fully realised, it did result in the large Ward Royal complex, award-winning at the time, and some extensive housing estates on farmland to the west.

The next thirty years saw many older buildings and long-established businesses disappear while new uses were found for others. In 1974, 700 years of independence came to an end on

the merger with Maidenhead to form a single borough, with most of the administration moving to Maidenhead.

Our book seeks to show how things have changed over the years by comparing views from the past with recent photographs. In some the change has been total, while others show a reassuring constancy. From Windsor Bridge it takes you on a roughly circular tour as far as Dedworth and Clewer. Emphasis is on the town itself, rather than the castle, which is well documented elsewhere. Limited space means that only a selection of the many available images has been included but we hope those chosen will be of interest to visitors and local residents alike.

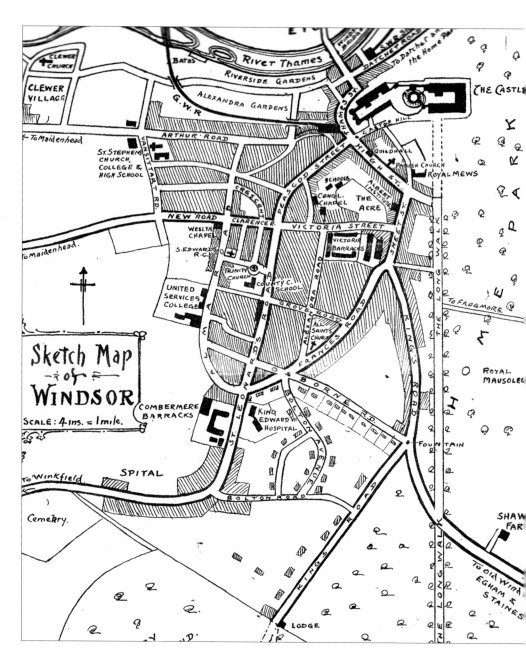

Sketch Map of WINDSOR

SCALE: 4 ins. = 1 mile.

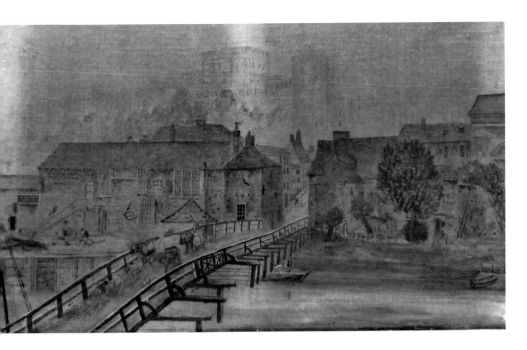

Windsor Bridge in the Eighteenth Century

In the past, Windsor relied on a succession of wooden bridges. These needed frequent repair and regular replacement. By the end of the eighteenth century it was decided a more permanent solution was needed and an iron bridge opened in 1824. Tolls and pontage were charged for passing over or under the bridge until 1898, when, after considerable pressure from the townsfolk, they were finally abolished. The bridge still stands but was closed to vehicles in 1970 after serious faults were discovered.

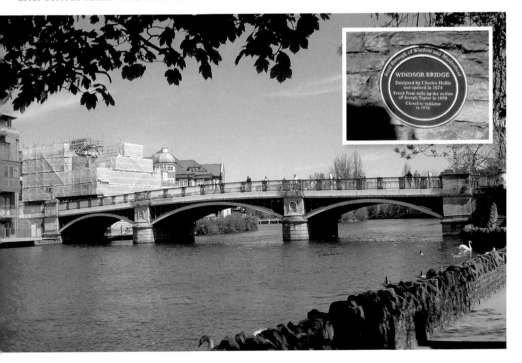

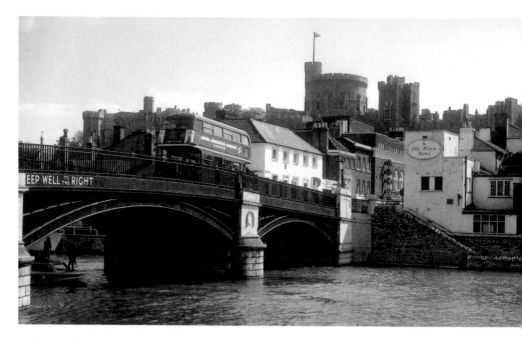

Bridge Traffic, 1969

In April 1969 a London Transport double-decker is seen crossing the bridge on the way to Langley Village, a year or so before closure. Traffic was then rerouted via the Windsor Relief Road, allowing pedestrians to stroll across at their leisure. In the background the sign for the ABC Cinema, Windsor's last cinema, is visible. It closed in 1983 to much local dismay. The Royal Standard flying over the castle shows the Queen was in residence at the time.

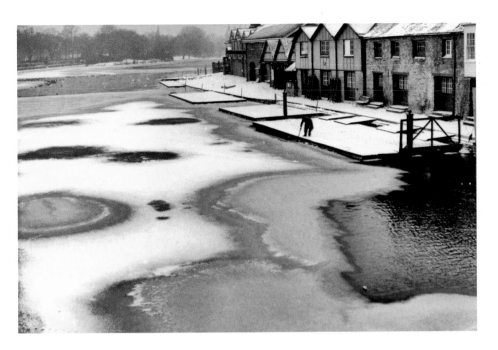

Views from the Bridge, 1963

A feature of the riverside were the Eton College boathouses, shown here in the winter of 1963 when little rowing was possible. With the opening of Dorney Lake, which was seen by millions during the 2012 Olympics, the college no longer makes use of the river, and the boathouses are to be replaced by exclusive riverside dwellings. Demolition took place during 2013.

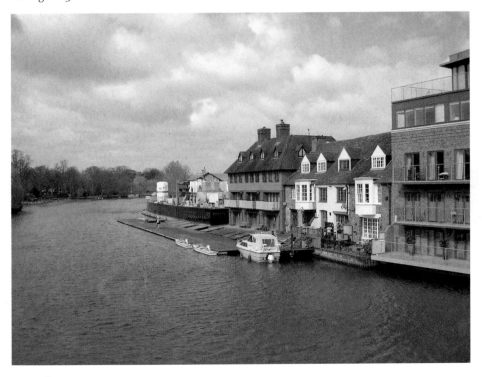

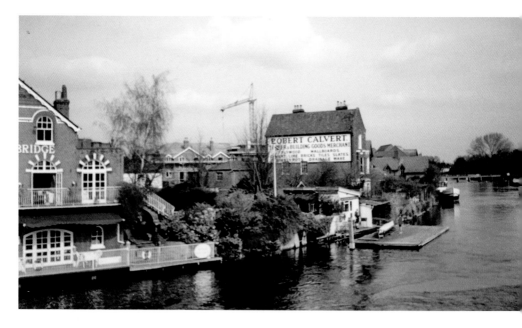

Trading on the River, 1970s

For centuries the river was the most important transport artery in the area. Goods were brought to the town in barges and manufactures sent to London. An important product of Windsor was beer from its numerous breweries. With the arrival of the railways, trade dwindled. One of the last commercial businesses on the river was Robert Calvert's timber yard. Latterly supplied by road, it finally closed in the 1980s and has been replaced by an apartment block.

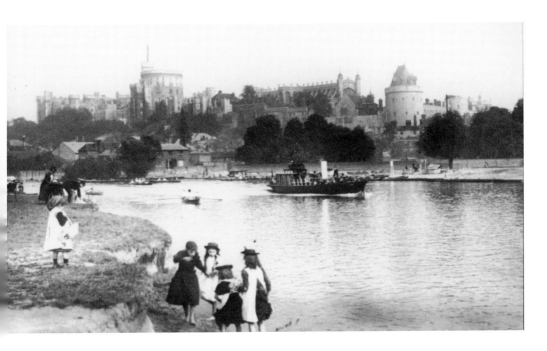

Pleasure Steamers, 1895

River trips have been popular with tourists for well over 150 years. Maidenhead, Marlow and Staines have been favourite destinations. One of the oldest companies, Salter Brothers, have been in business since 1858. Most boats are now run by a local company, French Brothers, who offer a frequent service of short and longer journeys during the summer months. Their vessels may lack the elegance of the Edwardian steamers but they are well patronised by the town's visitors.

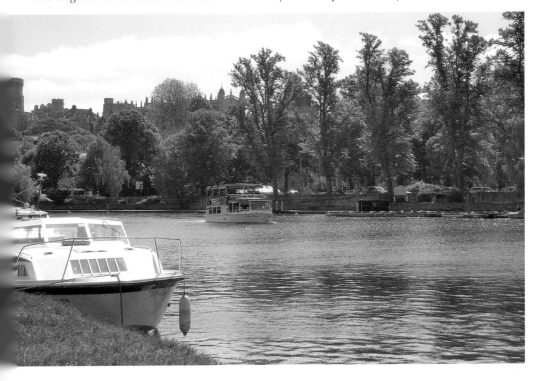

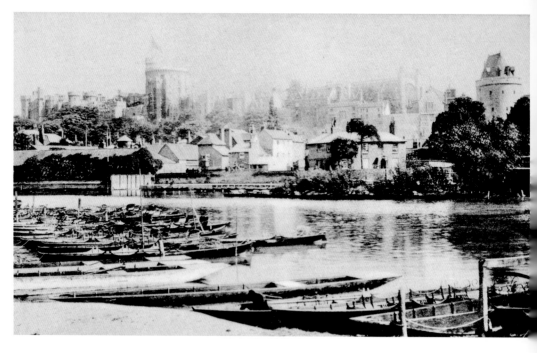

Jennings Wharf, 1890

Jennings Wharf was the main port for the barge traffic on the river. Behind the wharf was an area of warehouses, which survived the cessation of river trade and were only demolished in the 1990s to create a car park. During the 1930s, the wharf passed into the ownership of Courage Brewery, which donated some of the land to the town in 1938, allowing the creation of the riverside path that leads to Windsor Bridge.

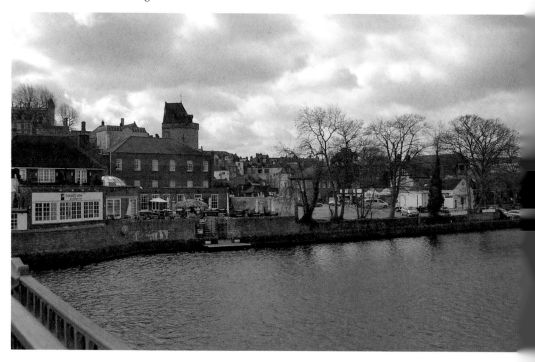

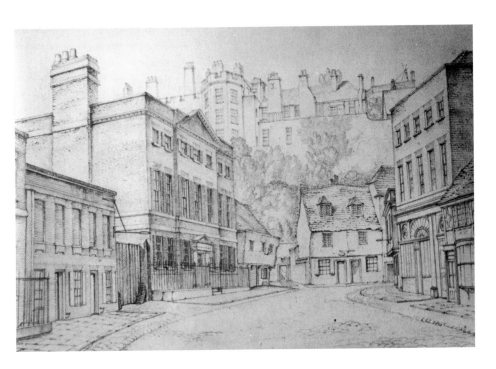

Old Bank House, 1798

Bank House has stood at the bottom of Thames Street since 1758, having been built for Henry Isherwood, brewer. It later became the Windsor Bank, owned by John Ramsbottom, banker, brewer and MP. It then became brewery offices for Neville Reid and was finally Courage's, which closed the site in 1962. It is now part of St George's School. Alongside is a memorial to Prince Christian Victor, a grandson of Queen Victoria, who was killed during the South African War in 1900.

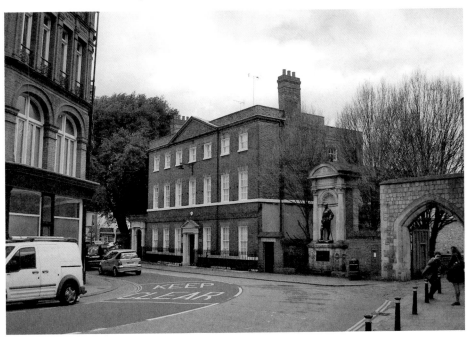

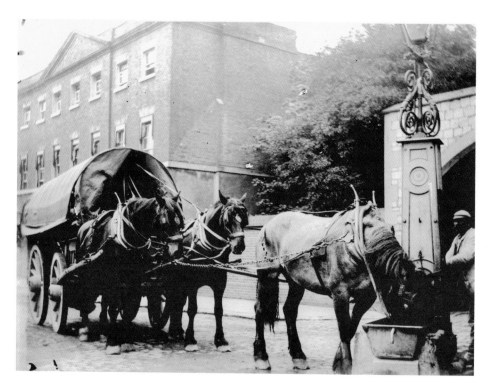

Horse Traffic, 1894

Windsor Bridge provided the only route for traffic coming over the river from Eton. Once across, the steep incline of Thames Street presented quite a challenge, and a pilot or 'cock' horse was kept by Bank House to assist wagons up the gradient. A water trough and supply of fodder were available here. Note that Prince Christian Victor's statue had not been erected at this time. Today, motor traffic climbs the hill with ease.

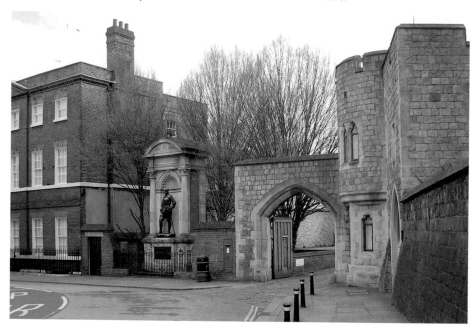

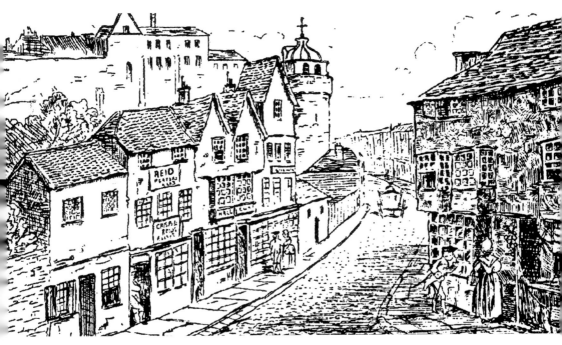

Thames Street Houses, *c. 1800*

As the town grew around the castle every piece of land was pressed into use. Houses lined the castle walls and Thames Street became very overcrowded. In 1848, the Windsor Castle and Town Approaches Act was passed leading to the clearance of these properties, which included shops and inns. The castle 'ditch' reverted to greenery once more. Trees have now grown along the lower part and higher up the ground is laid to lawn.

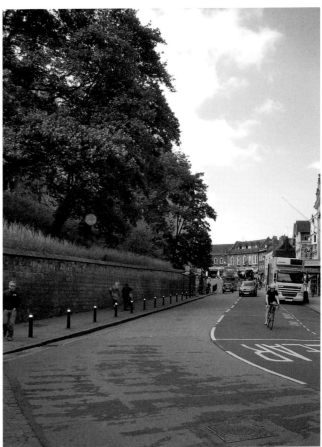

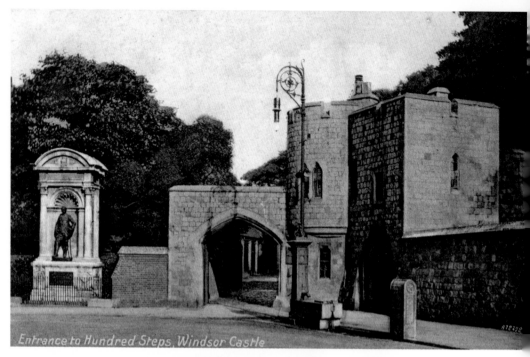

Entrance to Hundred Steps, Windsor Castle

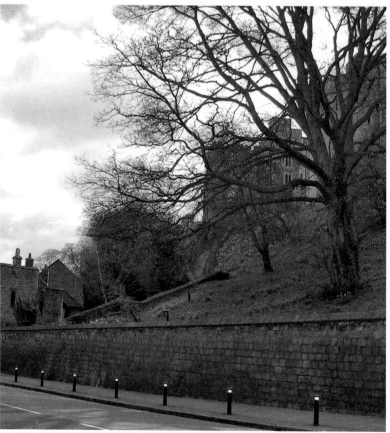

Hundred Steps, 1920s
The usual entry to the castle is via Henry VIII Gate on Castle Hill, but there was a shortcut between the cloisters and Thames Street. This was via the Hundred Steps, a steep and somewhat treacherous path apparently used by soldiers and, if the stories are to believed, by monarchs who escaped to enjoy the life below. The steps are now disused and overgrown but are still visible.

14

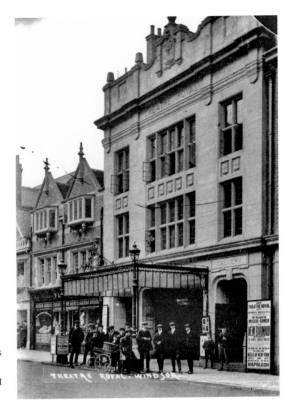

Theatre Royal, c. 1910
There has been a theatre in Windsor for well over 200 years. The Windsor Players performed in a barn at the bottom of Peascod Street in the 1770s. A permanent building was then erected in High Street and frequented by George III. Later, the theatre moved to Thames Street where it remains today. The current building dates from 1910, when rebuilding followed a disastrous fire. The Theatre Royal is famous for its pantomimes during the Christmas season.

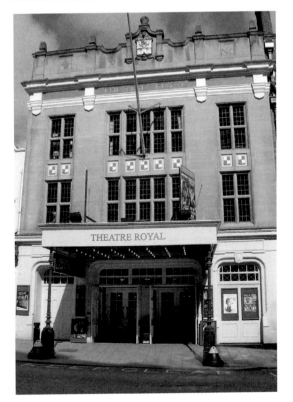

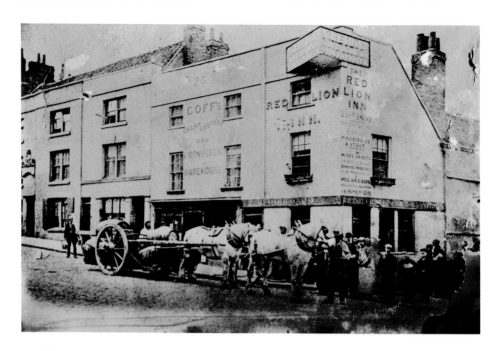

Red Lion Corner, 1890s

The Red Lion stood on the corner of Thames Street and River Street. The brewer's dray is heavily laden, so was probably on its way to the wharf, rather than delivering to the pub. River Street was known colloquially as Bier Lane, possibly because coffins came this way to go by boat to Clewer church for burial. Others believe it was because of the beer traffic that passed down it. A small square now occupies this site.

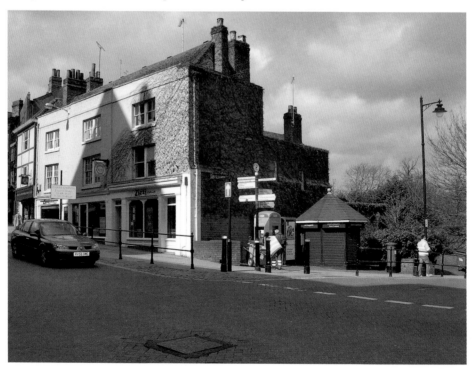

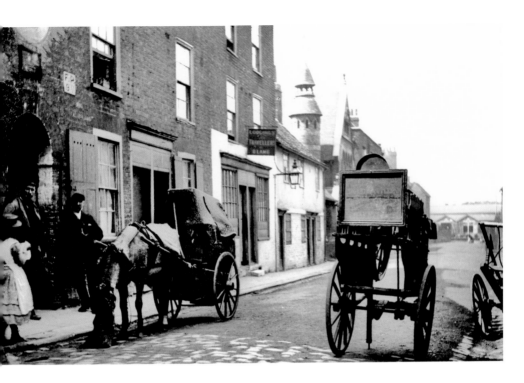

River Street, 1894

An 1890s view shows a quiet time in River Street. A knife grinder plies his trade while a trap opposite carries a barrel organ. Maybe the young girl was waiting for a performance. St Saviour's church can be seen in the middle ground and Eton boathouses are visible across the river at the bottom of the road. By the 1920s, this whole area had become an insanitary slum and was razed to form Windsor's first car park.

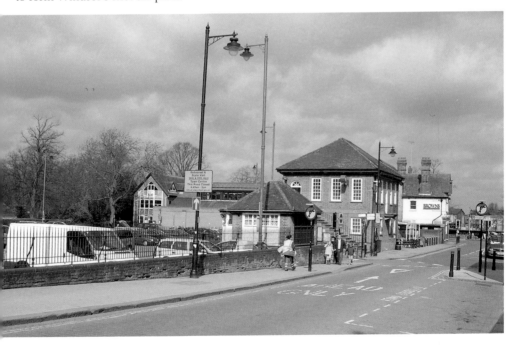

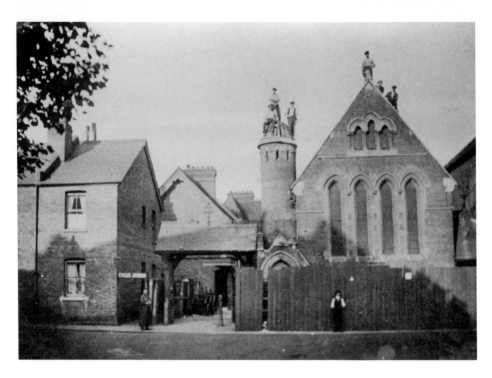

St Saviour's, 1920s

St Saviour's church was built in 1878 to provide for the needs of the population living in the mean streets by the river. It was to have a short life because of the River Street clearance. Here, the demolition gang is just starting work. The lychgate survived and was re-erected at the entrance to the Clewer Memorial Recreation Ground in west Windsor, where many of the families were rehoused. It still stands today.

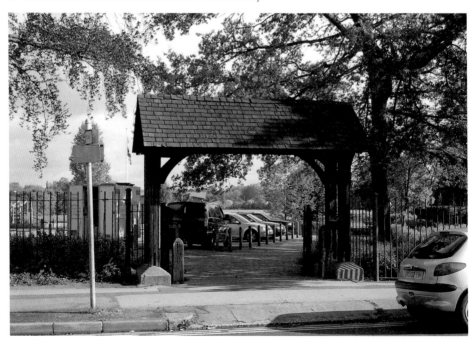

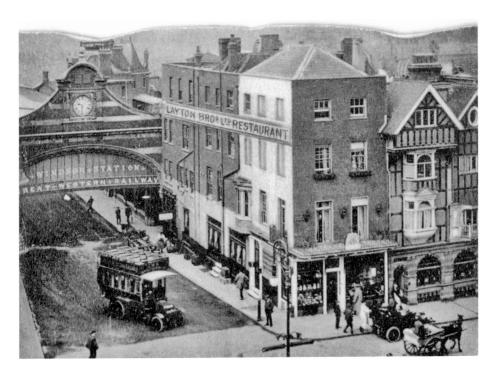

Layton's Corner, *c.* 1912

Layton's restaurant was an institution in Windsor for many years until its closure in 1939. It occupied the site opposite the Harte and Garter (formerly the White Hart Hotel) at the entrance to the Great Western Railway (GWR) station. In 1908, a grand reception was held to celebrate the Olympics. Today an off-licence and Lloyds Bank are located here, while the station buildings house restaurants and shops.

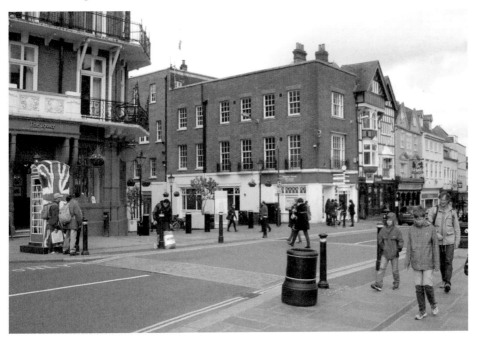

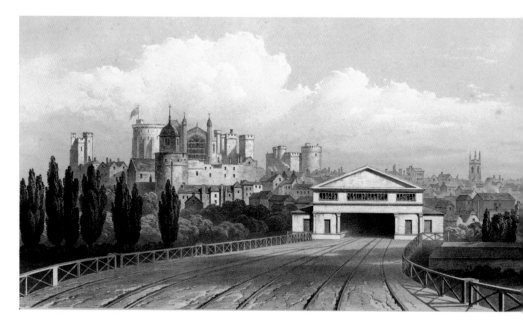

Great Western Railway Station, 1849

The railways came late to Windsor, having been strongly opposed by both Crown and Eton College, which was concerned about the boys escaping to London. Eventually, the GWR opened a branch line from Slough in 1849 that terminated in a train shed designed by Brunel on the site of the notorious George Street. In 1897, this station was replaced by a much larger one to commemorate Queen Victoria's Diamond Jubilee.

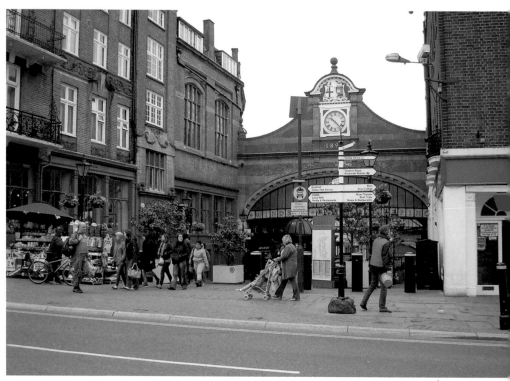

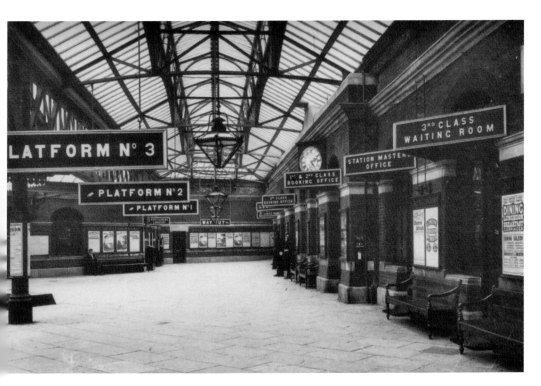

Station Concourse, 1901

The concourse of the 1897 station was a grand and spacious affair with a splendid array of signs. There were four platforms with all the facilities usually found at larger termini, including a busy goods depot. The building remains substantially unaltered today but houses shops and restaurants rather than would-be rail travellers. The old booking office is now the Tourist Information Office. The train to Slough runs from a single platform at the rear.

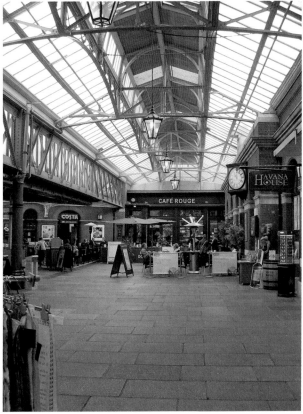

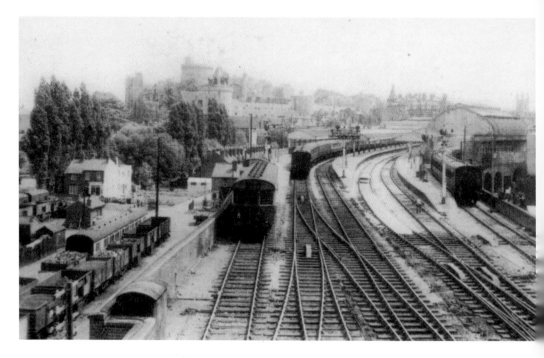

Railway Goods Yard, 1950s

Until the 1920s, the majority of freight was carried by the railways and most stations had extensive goods yards. Coal merchants and other traders had offices here and coal for Windsor gasworks was brought in. A steep gradient linked the upper station with the yard, which taxed the shunting engines of the day. The area now provides parking for the many tourist coaches visiting the town.

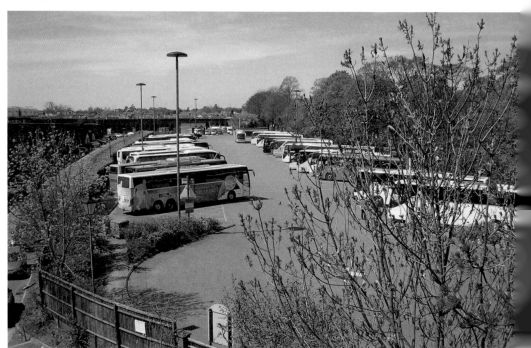

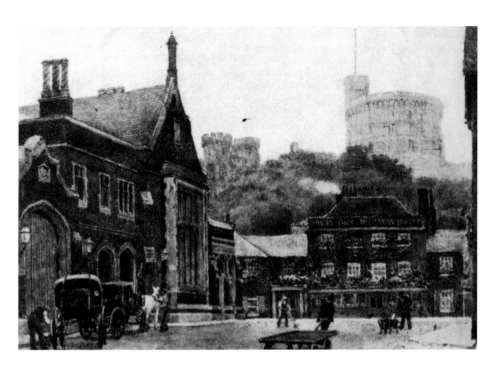

South Western Station and Farm Yard, 1890s

Although the GWR was the first line into Windsor, the South Western Railway branch from Staines was only a few months behind, built across land given by the Crown. An attractive station was built by Sir William Tite in 1851, which remains largely in its original condition. The cabs may have been replaced by taxis and the inn at the end of the road has been rebuilt, but otherwise the views from 1880 and 2013 have changed little.

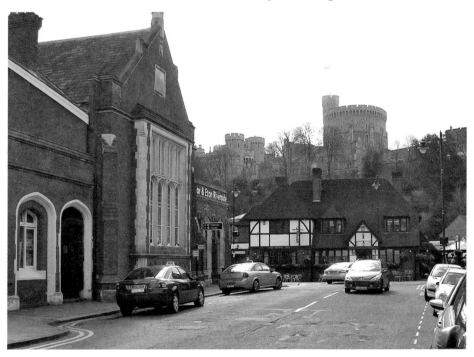

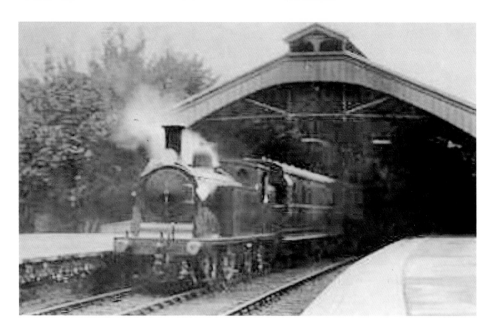

Trains at Riverside Station, 1920s & 2013

In 1930, the Southern Railway, with the help of government funding, electrified the line from Waterloo to Windsor, and steam engines were replaced by clean, fast, electric trains. Windsor Riverside remains a good example of a small Victorian terminus, although the Royal Waiting Room and large doors along platform 2 built to allow access for mounted cavalry make it unusual. The former ticket office is now a restaurant and music venue.

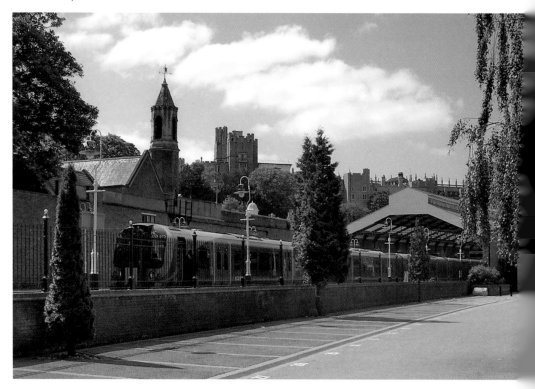

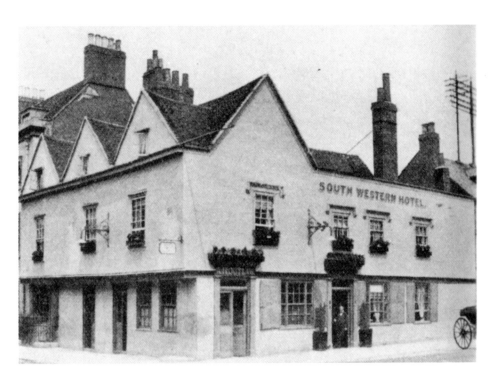

South Western Hotel, 1880s

When the railway arrived, the long-established pub on the corner of Thames Street and Datchet Lane became the South Western Hotel. Known for many years as the William IV, it has since become a restaurant and bar named the Bel & The Dragon. It is said that there has been a hostelry on this site since the twelfth century.

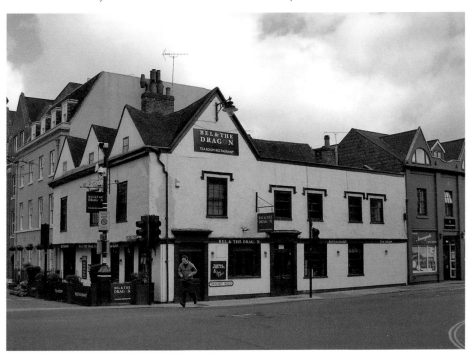

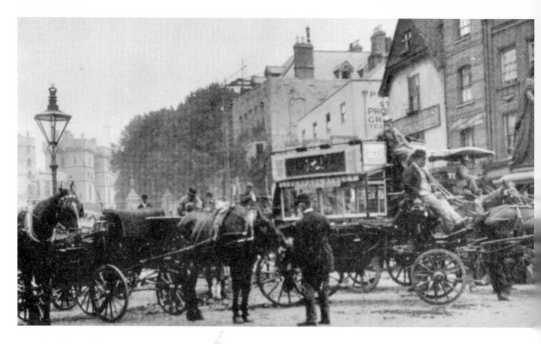

Castle Hill Traffic, 1898

Castle Hill was originally the main route for through traffic to Datchet and London. In 1850, two new bridges were built and the road through the park was closed, giving the Royals more privacy. Around the turn of the twentieth century, a London horse bus waits in the remaining section with other vehicles to take racegoers to nearby Ascot. Today the area is busy with tourists. Since 1887, Queen Victoria has looked down sternly from her plinth.

Buildings on Castle Hill, *c.* 1860

At one time, shops and houses lined both sides of Castle Hill, but those on the northern side were removed during the improvements of the 1840s and '50s. Charles Knight Senior, founder of the *Windsor Express*, had a shop here and later moved across the road into Brown's bookshop. A number of these buildings have survived, including the Horse and Groom and Edinburgh Woollen Mills, both of which are rumoured to be haunted. There was a Waitrose here in 1939.

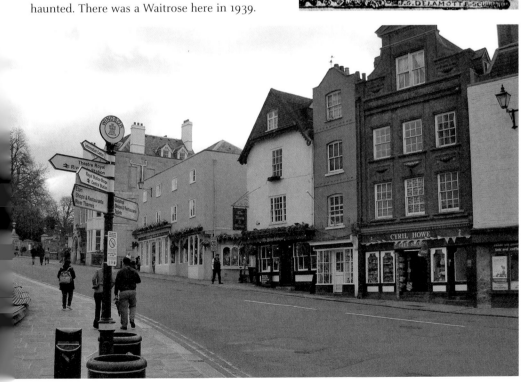

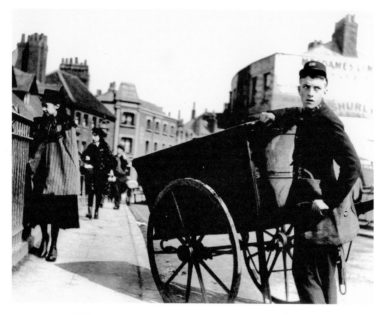

Delivering the Royal Mail, 1890s & 1970s
A Victorian postman pauses on Windsor Bridge with his mail cart as passers-by look down at the river. Some sixty years later electric carts were in use doing a similar job; one is shown here turning into Thames Street from Castle Hill. These too have now gone, to be replaced by vans or smaller hand-pushed trolleys.

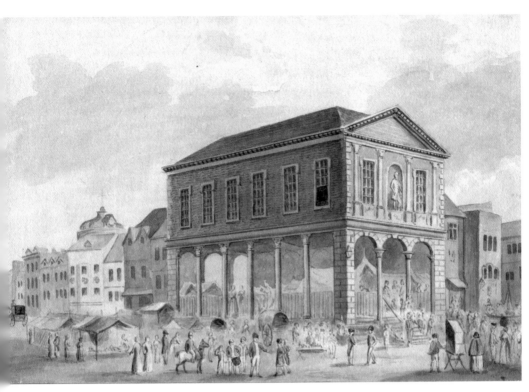

Windsor Guildhall, *c.* 1770
After the castle, the Guildhall is Windsor's most famous building. Completed in 1690 to replace an earlier Market House, the town council met here until the merger with Maidenhead in 1974. It is often said to have been designed by Christopher Wren but Sir Thomas Fitch was the architect. Today the Guildhall hosts a variety of functions and is a popular venue for weddings. Prince Charles and Camilla Parker-Bowles married here in 2005.

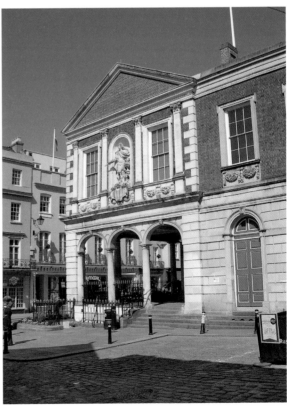

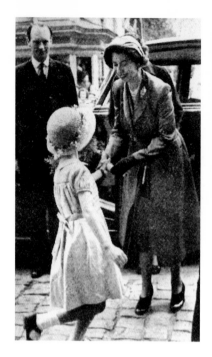
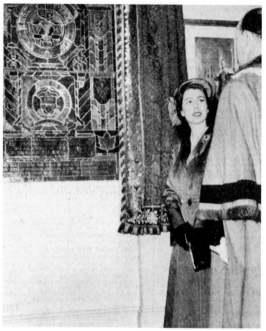

The Queen Opening the Guildhall Exhibition, 1951, and the Museum, 2011
The Guildhall was extensively refurbished in 1951 after years of neglect and was reopened by the then Princess Elizabeth. The ground-floor room included an exhibition of Windsor memorabilia and artefacts, which remained until 1983. In 2010, the Royal Borough Council decided a new town museum should be established in the Guildhall and this was officially opened by the Queen in December 2011.

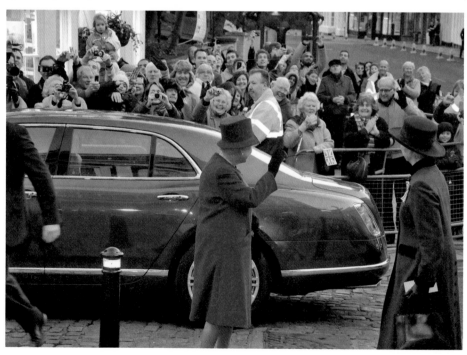

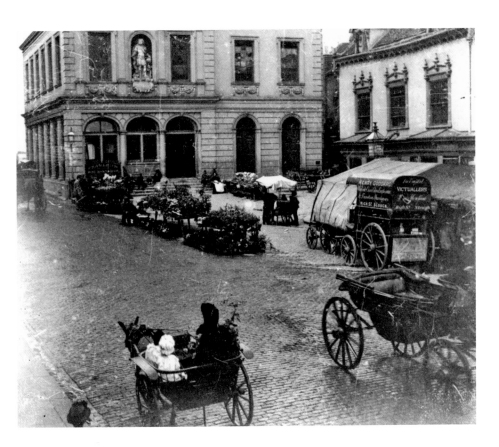

Flower Market, 1890s

For many years, the area around and beneath the Guildhall housed a market. The network of short medieval streets with its pubs and old houses remains, although stalls and butchers' shambles have long gone, leaving only the flower market to survive into comparatively recent times. Today the tradition has been revived with a farmers' market taking place once a month in St Leonard's Road.

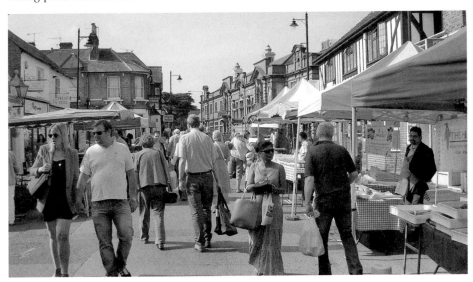

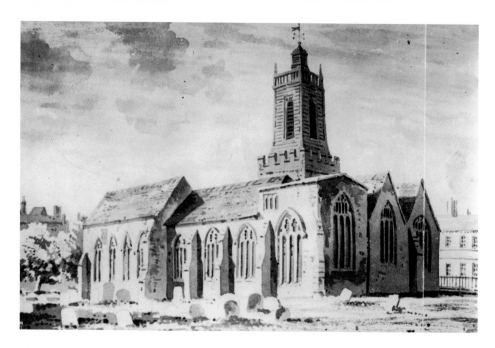

The Parish Church, 1800

The ancient parish church next to the Guildhall was in poor condition by 1820 and, after much discussion, it was demolished and replaced by a new structure dedicated to St John the Baptist. The contractor for the new building had championed the destruction of the old! An unusual feature was the cast-iron framing, although many Nonconformist chapels were later built in this way. The church still serves its purpose but is also used as a concert venue.

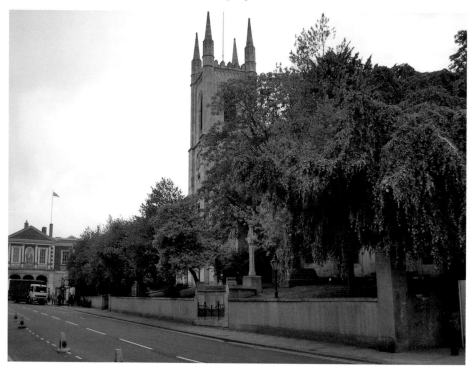

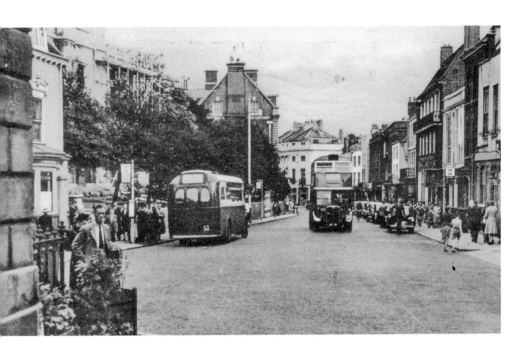

Buses in the High Street

Although there have been some changes, these two scenes are clearly of the same location. In 1955, a green London Transport Country Area bus heads off towards Windsor Bridge while a Greenline, probably bound for Staines, waits outside the parish church. Today a double-decker on Route 191 from Bracknell nears the end of its journey, while the blue bus is on Route 77 to Dedworth.

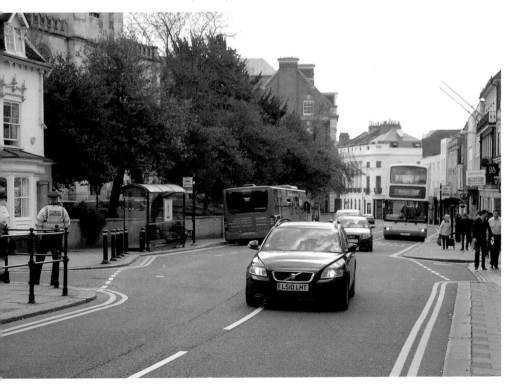

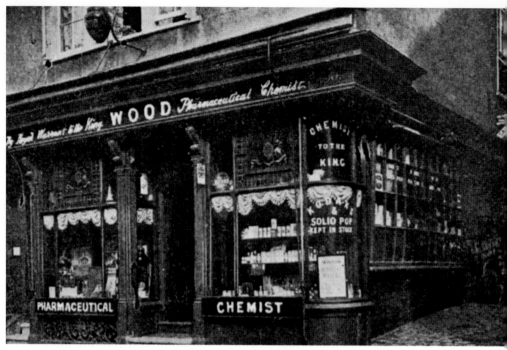

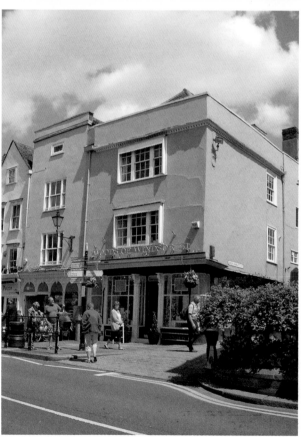

Wood's of Windsor, 1905
One of the oldest established Windsor stores, Wood's have been in business for well over 200 years. The 1905 picture shows them to be Chemists to the King but the trade now is in perfumery and similar goods. The adjoining Queen Charlotte Street, at 51 feet 10 inches long, is said to be the shortest in England.

The Royal Standard Public House, 1900

Possibly the most photographed building in Windsor, Market Cross House by the Guildhall has an interesting history. In 1718, a dispute over land ownership between Silas Bradbury, a butcher, and the council was resolved in the butcher's favour, and he quickly rebuilt his shop before an appeal was launched. Unseasoned timber was used causing the distortion. By 1900, the house was the Royal Standard Inn, shown as a print on a window blind in the museum. Today the 'Crooked House' is a tea shop.

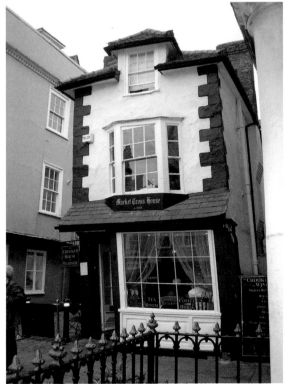

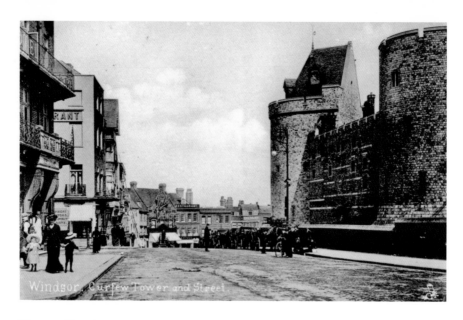

Thames Street, 1904

Thames Street leads down to the river and into Eton. Boots the Chemist announces its presence in the early years of the century with a large sign. Boots are now in Peascod Street and the premises are occupied by the King and Castle pub, but a steep passageway to the side, on land given by the company to the town, is still known as Boot's Passage. It leads down to Alexandra gardens and contains an interesting tiled map of Windsor.

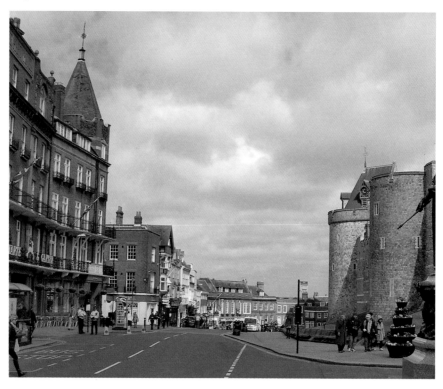

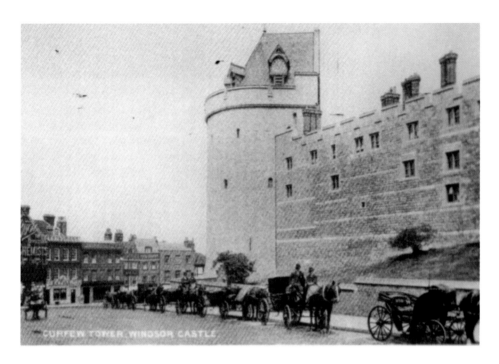

Cab Rank, 1900

There has been a cab rank in Thames Street for many years and it remains the place to find a taxi after a night out at the theatre or one Windsor's many restaurants. An interesting survival from the past are the iron hoops let into the kerbstones shown in the inset. These were for the cab wheels to rest against, preventing any runaways. Modern vehicles do not of course require such safe measures but they remain *in situ*.

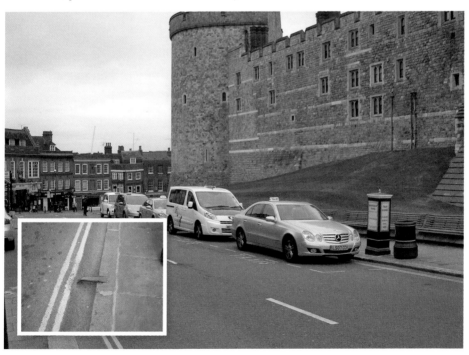

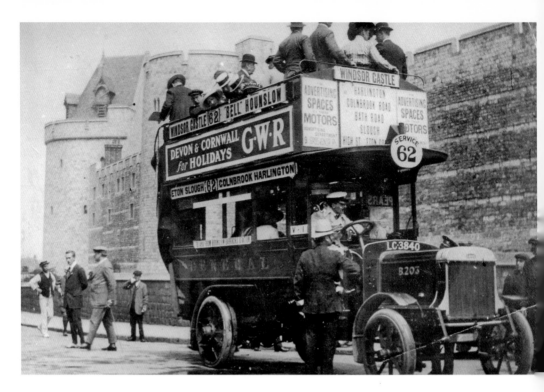

Tour Buses, 1912

Tourism has been a feature of the Windsor scene certainly since the arrival of the railways. The castle is a huge draw but there are many other interesting sights to be seen from the top of a bus. In 1912, the General Route 62 between Uxbridge and Slough was extended to Windsor at weekends to allow visits to the castle. Nowadays, dedicated tour buses take visitors around the locality.

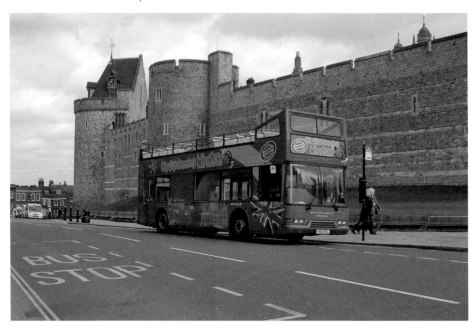

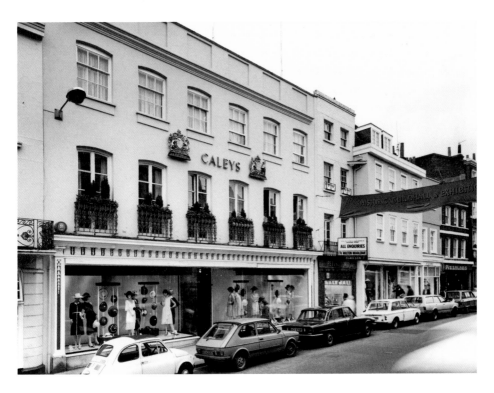

Caleys Department Store, 1981

Maria Caley opened her first dress shop by the castle wall in 1813. The store prospered, later moving to the High Street. It gained numerous Royal warrants, as can be seen in this 1981 view, by which time it was part of the John Lewis Partnership. A favourite destination for many Windsor shoppers until closure in 2006, it is still much missed. The site now houses TK Maxx on the lower floors and a hotel above.

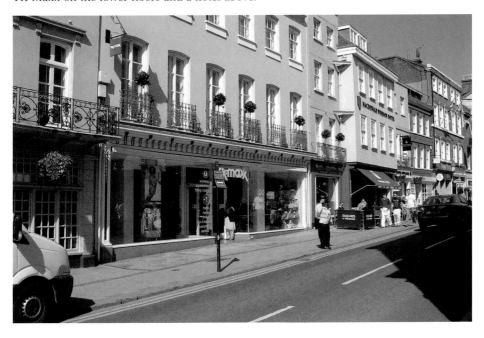

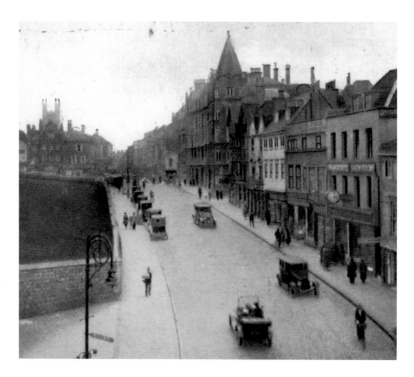

The Harte and Garter Hotel, 1920

Originally the White Hart Hotel, with the Garter Inn adjoining, the present building opened in 1899 when the proud boast was electric light in every room. Later, the name was changed to the Harte and Garter. Recently subject to extensive refurbishment, it dominates the top of the town and is a popular place both to stay and wine and dine. The Garter Inn was reputed to be where Shakespeare stayed when writing *The Merry Wives of Windsor.*

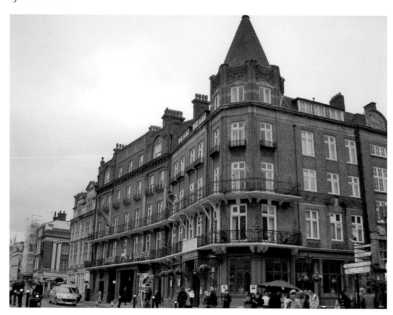

The Royal Free School, 1900

Tucked away behind the Guildhall in Church Lane is the Masonic Hall that once housed the Royal Free School, founded in 1705. It was paid for by public subscription with a donation from Queen Anne. Originally meeting in the church, it moved to the purpose-built premises on church land in 1725, accommodating forty boys and thirty girls from poor families, following a bequest of £500 by Theodore Randue, Constable of the Castle. The school later moved to Bachelor's Acre.

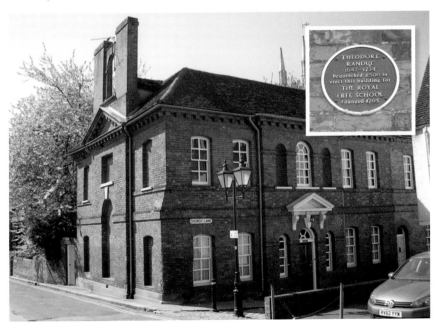

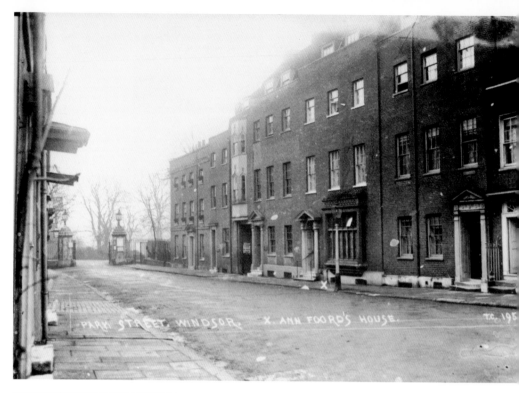

PARK STREET WINDSOR. X. ANN FOORD'S HOUSE. TC 195

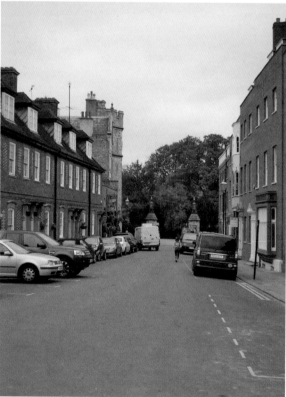

Park Street, 1890s
Lined with elegant Georgian houses, Park Street was originally part of the road to Old Windsor and beyond. The route was closed during the improvements of 1850, making it a residential street, housing some of Windsor's leading citizens. This remains true to an extent today, although many of the houses have been converted into offices or apartments. At the end of the street is a well-known hostelry, the Two Brewers – a favourite with visitors and locals alike.

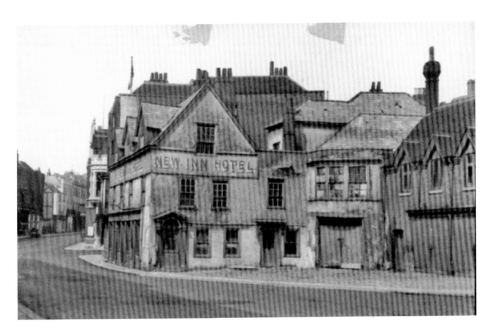

The New Inn, 1930

At the other end of Park Street stood the New Inn, one of the oldest buildings in town, which had its heyday when horse-drawn traffic travelled through to Staines and London. It was demolished in 1931, leaving an open area in front of the post office. Today a statue marks the Irish Guards association with Windsor, while the blue pillar box was erected to commemorate the fiftieth anniversary of the first aerial post from Hendon to Windsor in 1911.

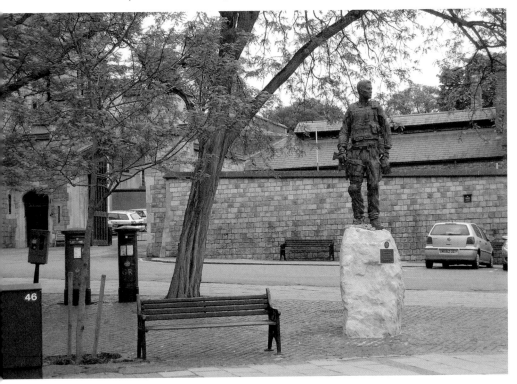

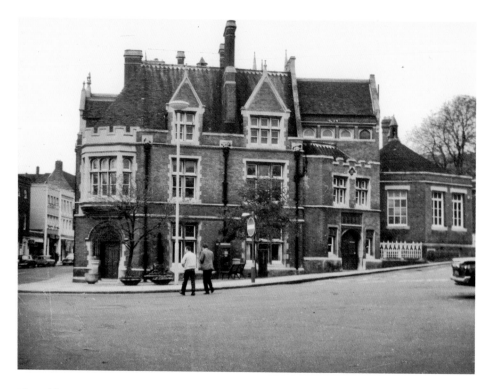

The Old Post Office, Sheet Street, *c.* 1970

Windsor's post office moved to a site next to the New Inn in 1841. The increasing demand for postal services towards the end of the nineteenth century led to the opening of new premises on the corner of High Street and Sheet Street in 1887. By 1967, a more convenient location was sought and the post office was transferred to the main shopping area in Peascod Street. The old building came down in 1972 to be replaced with an office block.

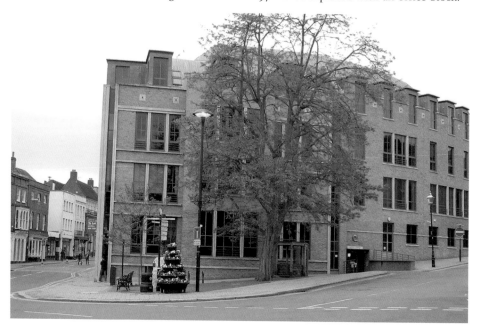

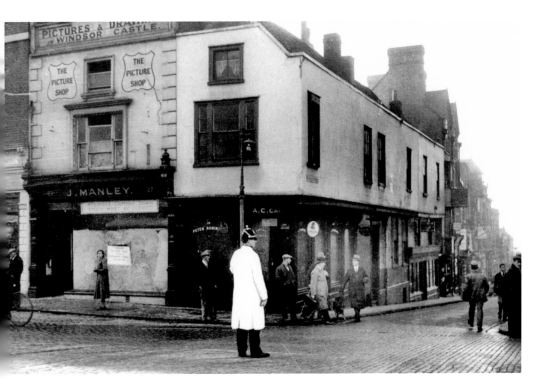

Caffyns Corner, 1930
Peascod Street was a convenient route from Castle Hill to the bottom of the town, and carried increasing amounts of traffic as the population and trade grew. Access from High Street was restricted by the presence of two shops, one of which was an outfitters, Caffyns, which gave its name to the corner. In 1930 this and the adjoining shop were removed, and the road was widened. Subsequently, a Montague Burton store was built on part of the site, now occupied by Barbour.

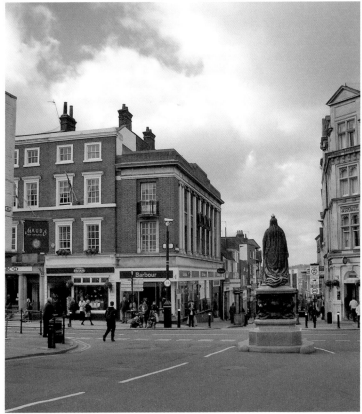

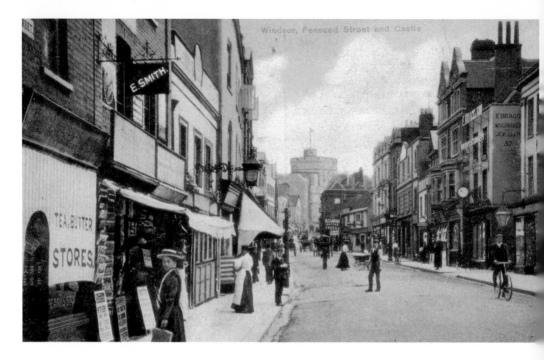

Peascod Street, c. 1905

The commercial centre of the town gradually moved into Peascod Street during the nineteenth century. In 1900 there was plenty of room for pedestrians to stroll between the shops. These were mostly small retail outlets, with provisions and clothing being the main trades. By the 1930s, motor traffic had begun to invade and shoppers had to be wary of cars. Two of Windsor's three cinemas were in Peascod Street; the Empire survived until 1959 and the Regal some ten years later.

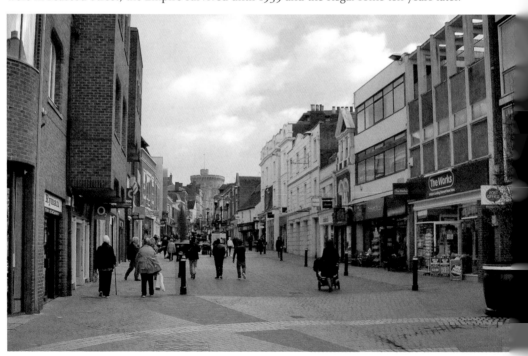

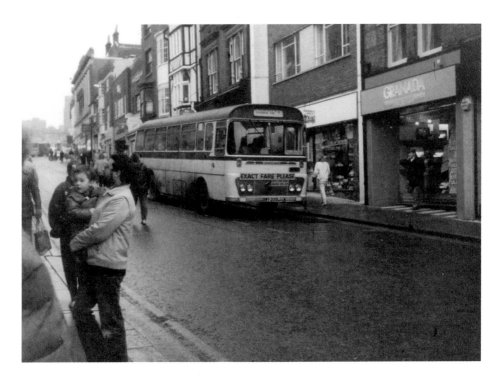

Imperial Bus to Dedworth, 1987

From 1926 to 1987 Windsor had its own local bus service, Imperial, run by A. Moore & Sons. As west Windsor was developed as a residential area, the routes were extended to cater for the many new residents. It was a friendly concern and was much mourned on its closure. The picture shows the 'Brown Bus' during one of the last days of operation. Peascod Street is now pedestrianised with only some upper storeys of buildings showing their Victorian origins.

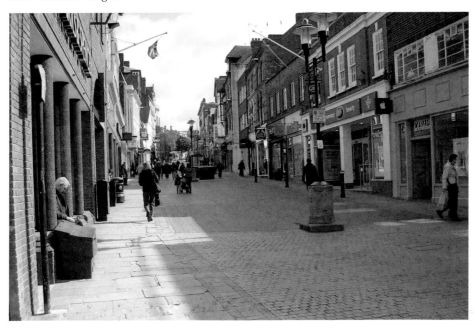

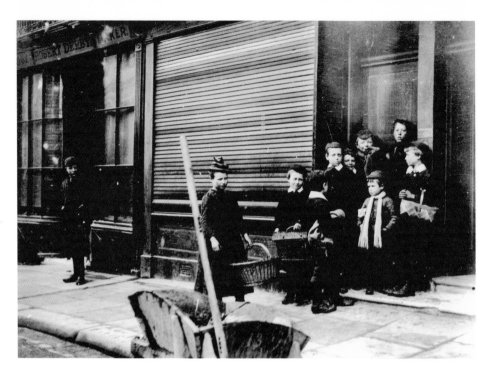

Eating and Drinking, 1895

In August 1895, a group of children wait for the baker's to open, hoping to buy yesterday's loaves, which were sold cheaply. A road sweeper's barrow stands outside, the broom handle being marked with the borough insignia. Today, in a more affluent age, one can sit outside and enjoy a cappuccino, at one of the many pavement cafés that have sprung up along the street, while having a break from shopping.

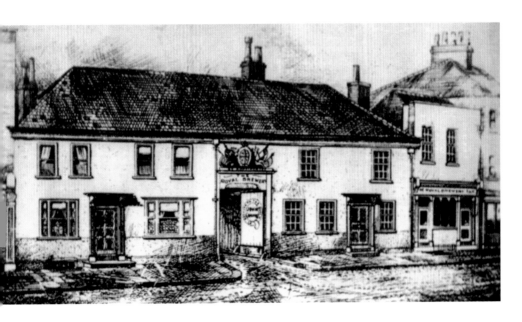

Cannings Brewery, 1846

The print of Cannings Brewery shows what Peascod Street was like before substantial development occurred later in the Victorian era. Today, no trace remains but a rare Tudor survivor from 1582 still stands opposite. A former inn, it was extensively refurbished in 1970s and now houses the Oxfam shop and a florist. Alongside is Hunt's the butchers, the last shop of its kind in Windsor. Somehow it has avoided being squeezed out by cafés, mobile phone shops and estate agents.

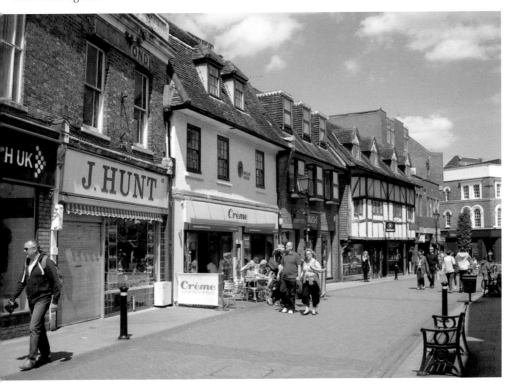

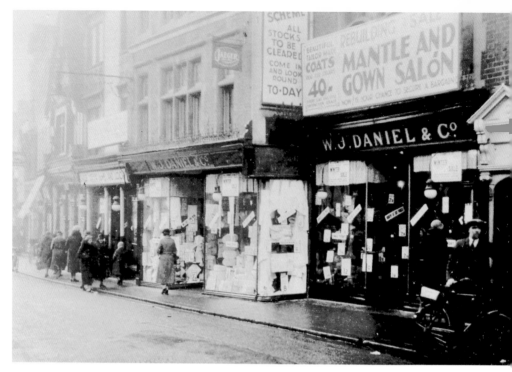

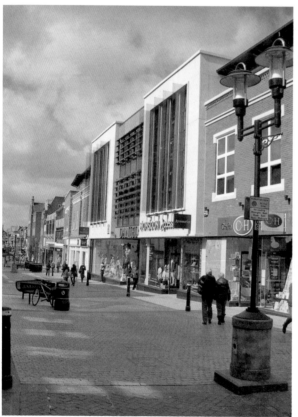

W. J. Daniel & Co., 1920
An institution in Windsor, Daniel's department store has been in Peascod Street since 1918. Initially trading from a series of adjoining shops, a new building was erected in the 1920s but this has recently been replaced with a smart modern store on the same site. Since the closure of Caleys', Daniel's is Windsor's only department store and always does good business during its famous sales.

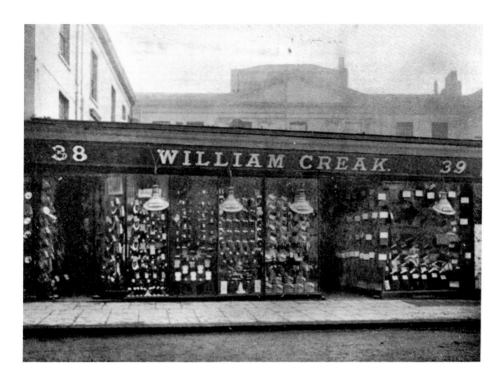

William Creak, 1900s

Creak's occupied a number of premises in Peascod Street, with the gents outfitters carrying a wide range of stock. Behind the store stood the house of Henry Darville, the town solicitor, and beyond that was the Congregational church. The store closed in the 1950s and the site was cleared to make room for a new post office building and sorting office which remain today. Fred Fuzzens, a well-known local postman and historian, is commemorated by a plaque outside.

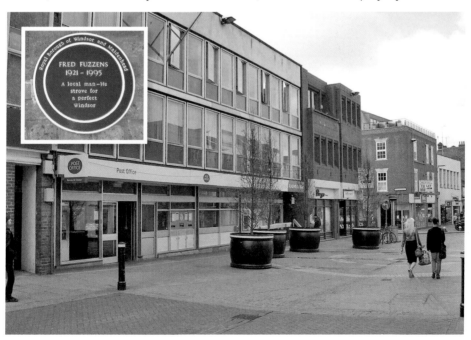

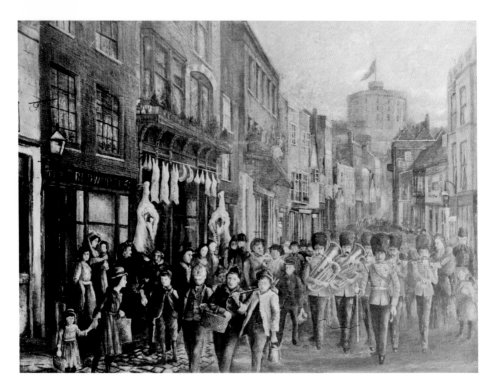

Guards Marching, 1890s

A popular occurrence in Windsor is the daily changing of the Guard. Soldiers march from Sheet Street Barracks up to the castle to relieve the nightwatchmen, who return soon afterwards. At one time, the route took them straight down Peascod Street as this early print shows. The butcher's shop then held plenty of produce! Today the route is up Sheet Street and into High Street, past the Guildhall. People still enjoy watching and listening to the band.

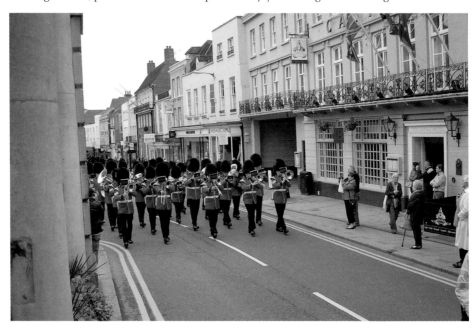

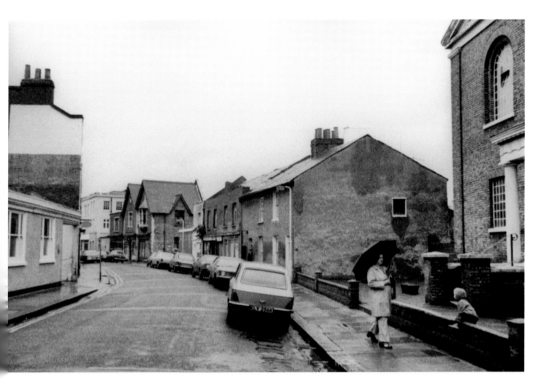

William Street, *c.* 1970
William Street fell victim to
some drastic redevelopment
during the 1970s. By then
many of the properties were in
a poor state and had outlived
their usefulness, although
today some of them might have
been considered worth saving.
However, all was swept away
and new buildings housing a
nightclub, a supermarket (now
closed), and several smaller retail
outlets appeared in their place.

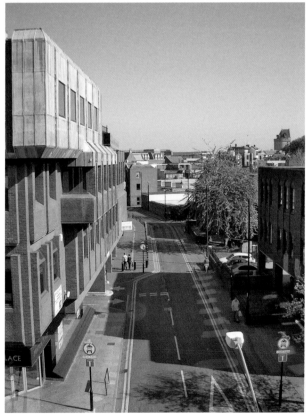

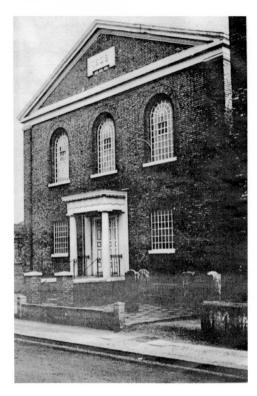

The Congregational Church, *c.* 1970
By 1969, the Congregational church, built
in 1836, was in poor condition, and with
redevelopment in the offing it was not
deemed worth saving. As part of the scheme, a
new church was built – the United Reformed
church, seen here. Although well designed
internally, the choice of brick colour makes it
rather sombre from the outside. The bollards
are to control the nightclub traffic.

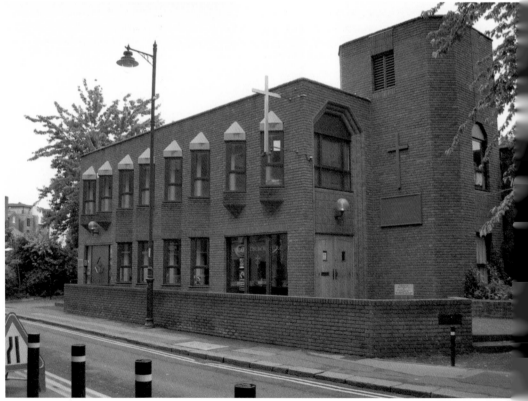

Barkers Garage, *c.* 1970

Having originally been constructed as a coachbuilder's works, Barkers adapted to the motor age and it became a garage and filling station. Externally little had changed for many years, and to the student of architecture it was a fascinating survival. Nonetheless, it came down to be replaced by a large new building containing Blazers Nightclub. This has since become 'Liquid' and is very popular with the young.

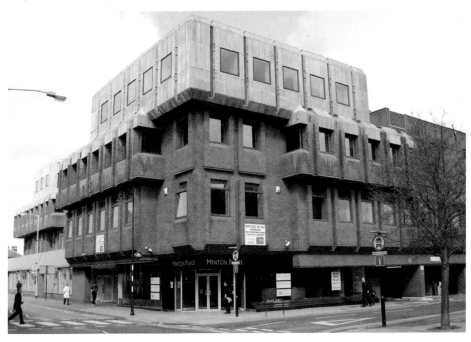

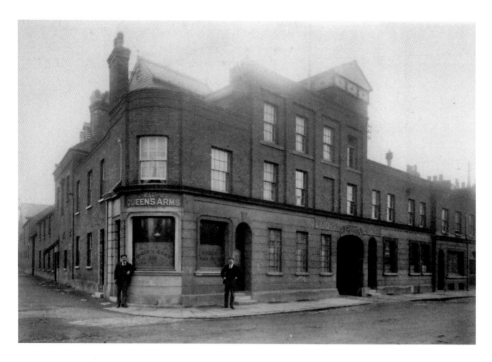

Burges Brewery, 1920s

Victoria Street was cut through in the 1840s to provide a quicker route out to the west of Windsor. New buildings sprang up; among them was Burges Brewery. This provided beer to many local public houses until its closure in 1932. Following that, it found various uses until demolished to make way for a multistorey car park as part of the redevelopment of the William Street area.

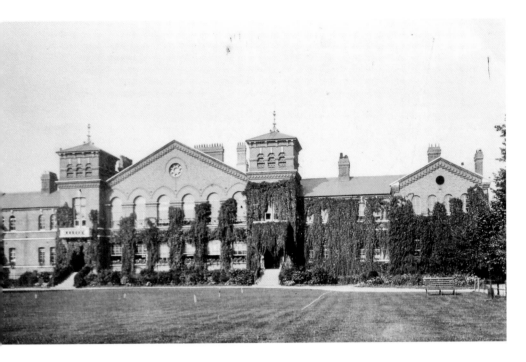

Victoria Infantry Barracks, 1880s

In the early days of the Army, troops were accommodated in inns and lodgings within the town. In 1803, an infantry barracks was established in Sheet Street. This was enlarged over the years, absorbing some of the surrounding streets. It was named the Victoria Barracks after renovations in 1867. In the 1980s, the old buildings were replaced with accommodation much more fitting for a modern Army. The two views here show the Officers' Mess before and after the rebuilding.

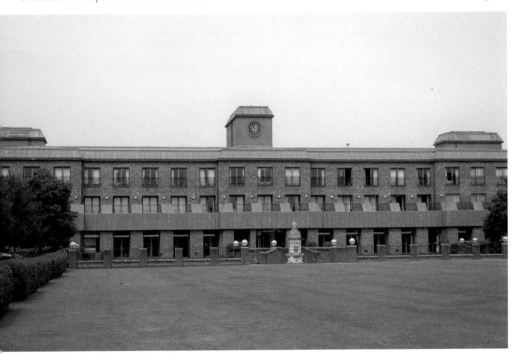

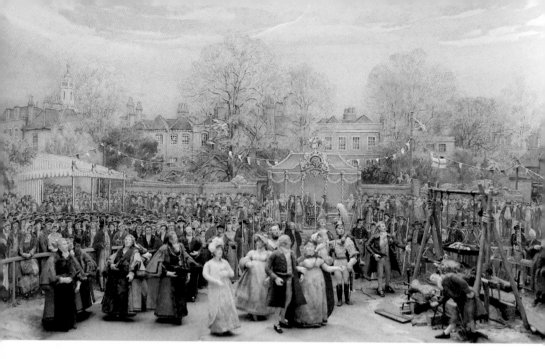

Bachelors' Acre Diorama, 1950s, Showing a Scene from 1809

Bachelor's Acre has been a town green for centuries, although it has almost been lost on several occasions. In 1809, an ox roast was held to celebrate King George III's Golden Jubilee but he was too ill to attend. This is captured in one of several dioramas made in the 1950s by Judith Ackland and Mary Stella Edwards, now on display in the Guildhall Museum. Today the Acre is a much valued open space for all to enjoy.

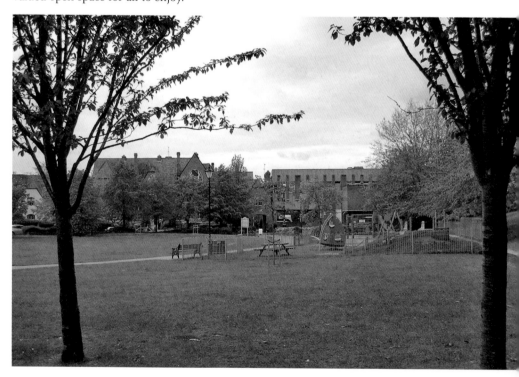

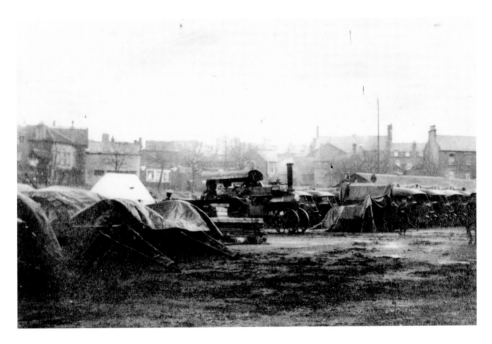

The Acre, During the First World War, 1915

During the First World War, the Acre was a storage area for the Army, whose barracks were opposite. The 1915 view shows Crossley tenders, a traction engine and guns awaiting dispersal. In the 1950s the whole area was asphalted over to provide a playground for the school and a car park. When the school moved, the car park was to be extended, but due to the efforts of one woman – Doris Mellor – the Acre was reverted to a town green.

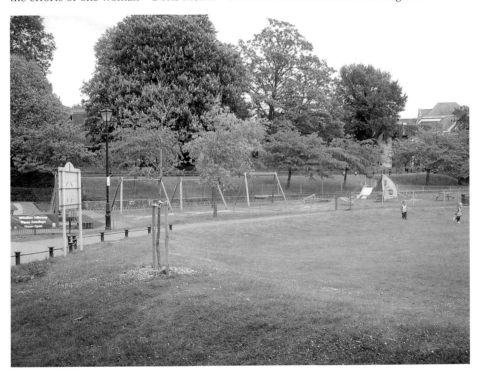

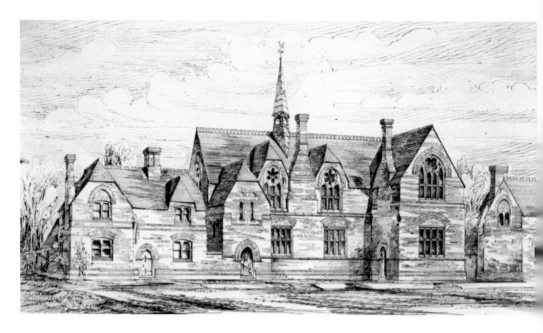

Royal Free School on Bachelors' Acre, 1859

The Royal free school outgrew its premises in Church Lane, merging with the national school in 1859 to occupy a new building on the Acre. The adjoining houses were for the headmaster and his assistant. It still stands today, although no longer in educational use. The public library now occupies a site behind it. The Royal Free School merged with Princess Margaret Rose School to form Princess Margaret Royal Free School in the 1970s, only to close in 2000.

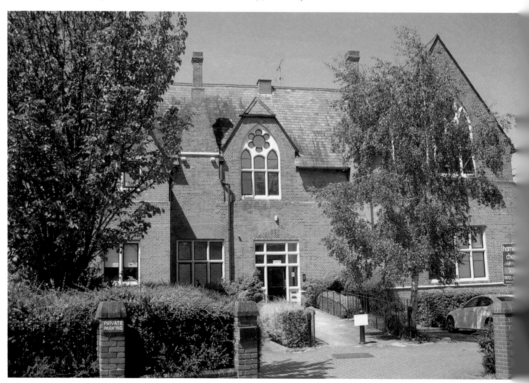

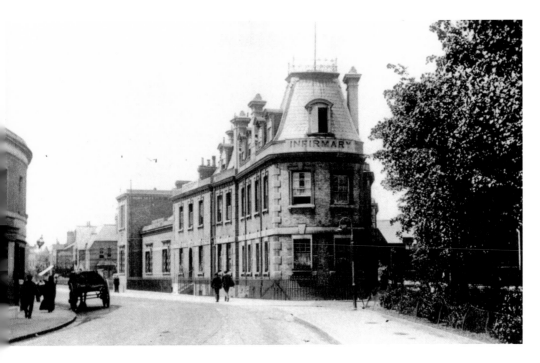

Windsor Infirmary, 1890s

Another important building erected on the Acre was Windsor Infirmary, which replaced the Free Dispensary, dating from 1818, in 1834. Despite later extensions it became too small for its purpose. In 1907, a new, much larger hospital, the King Edward VII, was opened along St Leonard's Road. The infirmary, like the nearby brewery, survived for some years, housing the Liberal Club, which still meets in the office block erected on the site in 1973.

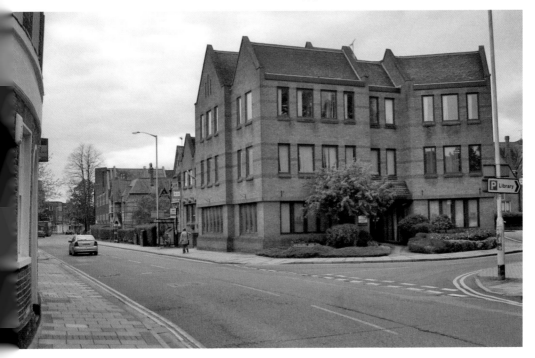

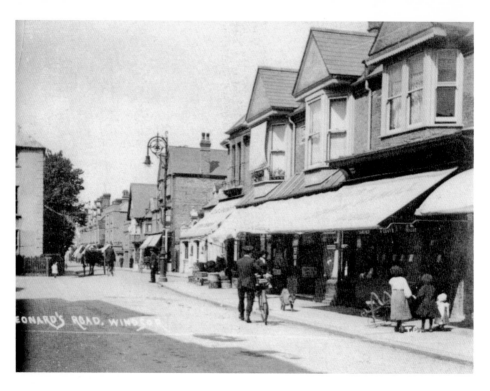

St Leonard's Road, 1900

Slightly away from the main town, St Leonard's Road has a character all its own. Although many have gone, a number of independent shops remain along the street and its appearance has not changed a great deal over the last century or so. The magnificent street lamps were lost, although recently some attractive modern ones have been erected. For centuries known as Spital Road, it led out of town to the St Peter's Leper Hospital.

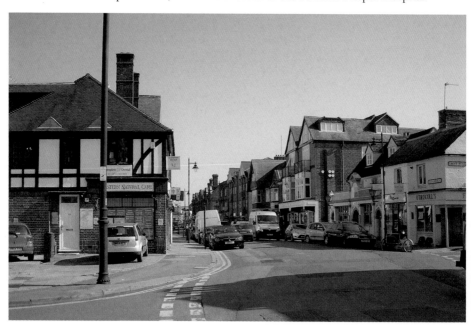

St Leonard's Road Cedar Tree, 1910

A notable feature of St Leonard's Road is the cedar tree that dominates the southern end. The tree was originally in the grounds of a large house, the garden of which was built on in Edwardian times. It survived and continues to flourish, although it had a narrow escape in 2011 when the council decided to fell it to prevent further damage to neighbouring properties. Such was the outcry, they rethought the idea and St Leonard's Road has kept its landmark.

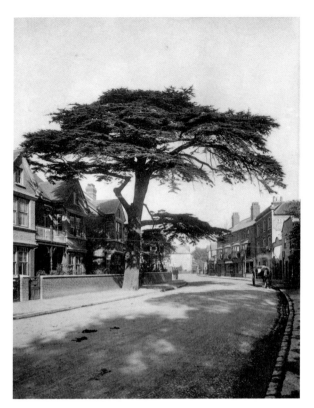

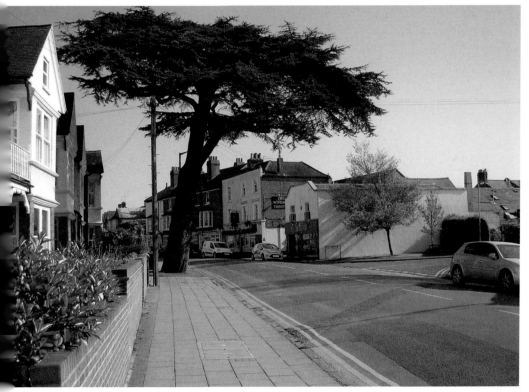

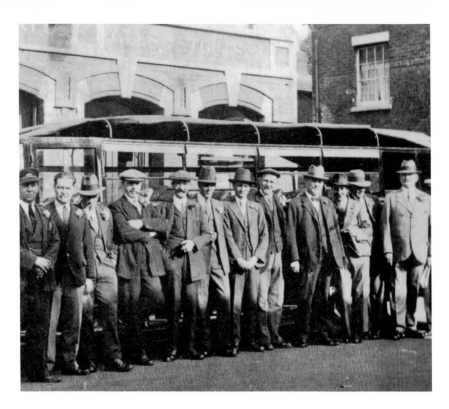

The Herts Arms Public House, 1920s

Windsor was a town of numerous pubs and inns, supplying the needs of both local working men and the soldiers from the barracks. The years have seen a great diminution in number, with many being demolished and replaced by residential or commercial accommodation. Some buildings have survived and the Herts Arms in St Leonard's Road, the starting point for a charabanc trip in the 1920s, is now a hair salon.

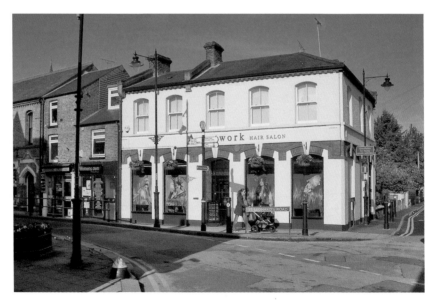

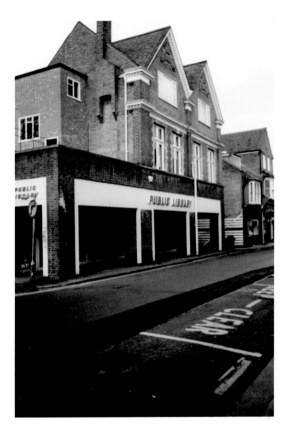

Public Library, 1990
The land around Holy Trinity church
has been council-owned for many years.
Originally the site of the Windsor Boys'
Grammar School, it was later occupied
by East Berks College, while the public
library stood on the St Leonard's Road
frontage. When this moved to Bachelors
Acre in 1995, the building became a
furniture shop but was later demolished
to make way for the new college building.
In keeping with the area, elegant town
houses now grace the old site.

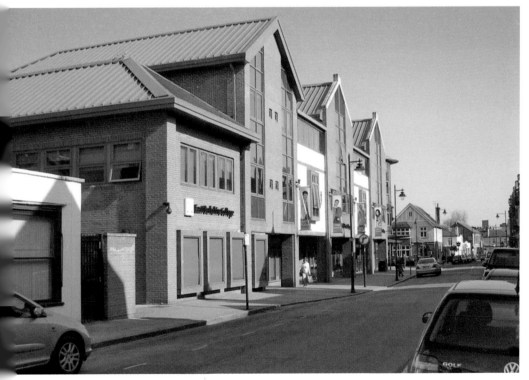

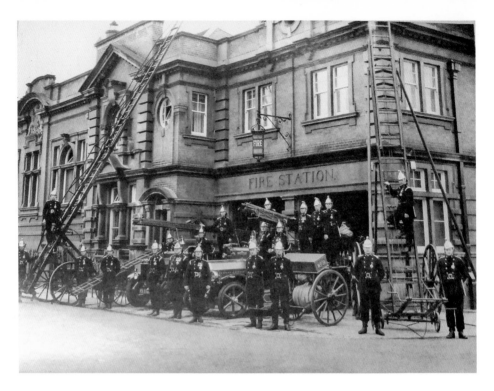

Police and Fire Station, 1935

A new police station was opened in 1905 replacing a row of houses called Keppel Villas. The building included the magistrates' court and a fire station, which by 1935 housed motor fire engines. Both police and firemen have moved to new premises, although these too may soon be closing. The Firestation Arts Centre now occupies part of the building while the remainder is used as offices. Since 1999, the magistrates' courts take place in Slough and Bracknell.

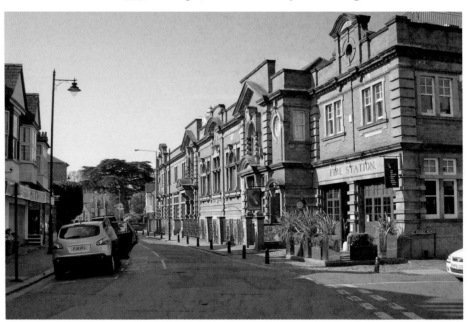

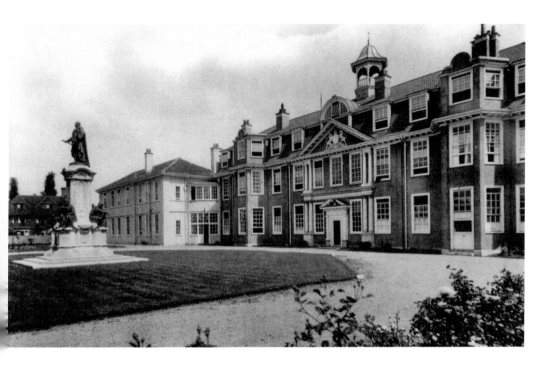

King Edward VII Hospital, 1912

The new King Edward VII hospital was opened with great fanfare in 1907. The following year a commemorative stone was laid by the King, accompanied by Queen Alexandra and the Prince and Princess Christian. A large and elegant building, it now houses a number of specialist clinics, including the Prince Charles Eye Unit – one of the best in the country.

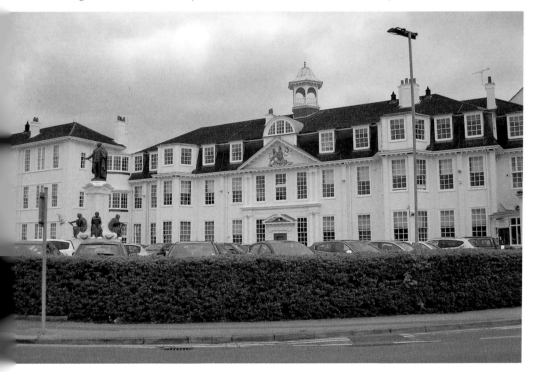

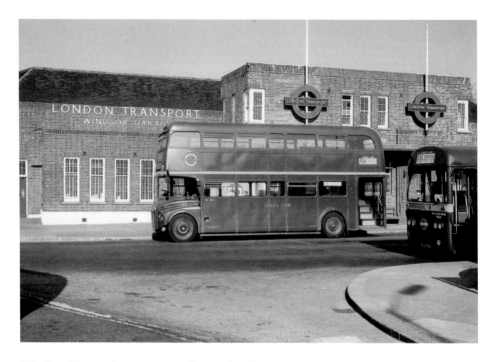

Windsor Bus Station, St Leonard's Road, 1969

When the London Passenger Transport Board was formed in 1933, a building programme saw the construction of many new bus garages. Windsor bus station and garage, sited opposite the hospital, became a centre for many Country bus and Greenline services. In 1970, a year after the scene shown here, a rationalisation programme began leading to eventual closure in 1984. A large apartment complex now occupies the site and a single bus route operates to Heathrow.

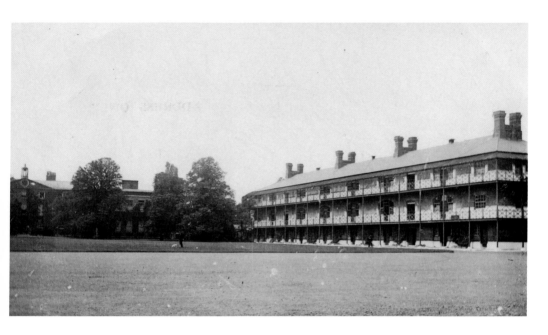

Combermere Barracks, 1880s

The Cavalry Barracks were established in the Spital area in 1804. Later named after Lord Combermere, colonel of the First Life Guards from 1829 to 1865, it still houses horses used for ceremonial occasions, but the Guards are an active unit and have been in Afghanistan in recent years. The modern buildings are great contrast to the earlier colonial style. The small willow tree grown from a sapling taken from Ypres commemorates the First World War.

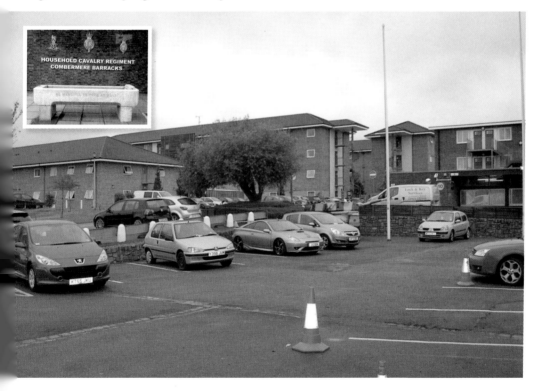

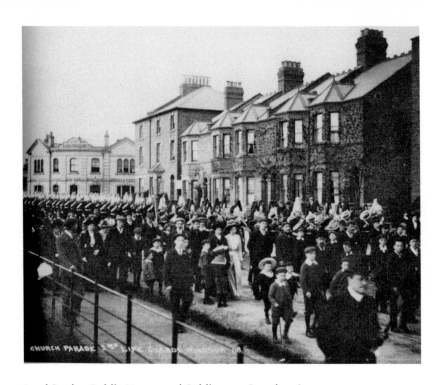

Lord Raglan Public House and Soldiers on Parade, 1890s
The Lord Raglan was a well-known Windsor pub and, being close by the Combermere Barracks, was never short of military custom. It can be seen in the background in the upper picture as the Guards march past on the way to church parade in Holy Trinity church during Edwardian times. All the earlier buildings including the pub have now gone and the road layout altered. The army would not take this route today.

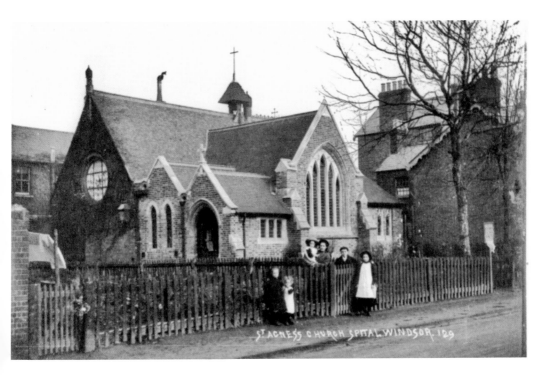

St Agnes Church Spital, 1890s

Originally the location for St Peter's Leper Hospital, the area known as Spital expanded considerably during Victorian times. In 1874, the rector of St Andrews Clewer, Canon Carter, had this small church built at his own expense and it is still part of the combined parishes of Dedworth and Clewer. In recent years it has been much restored and is now home to St Agnes Fountain Music and Faith Centre, widely used by the local community.

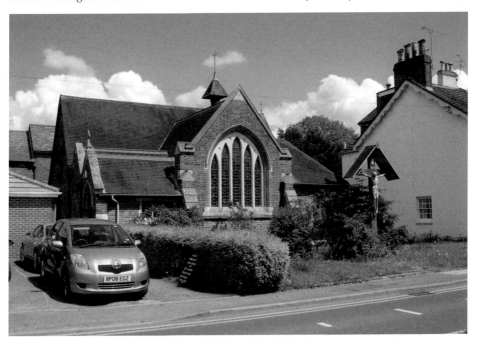

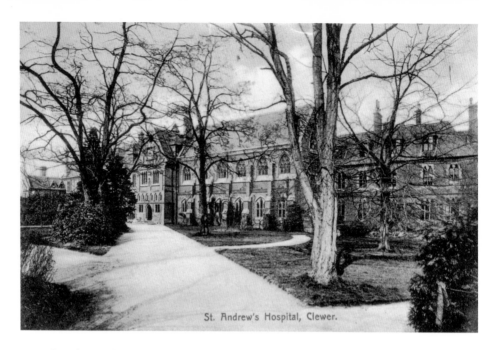

St. Andrew's Hospital, Clewer.

St Andrew's Hospital, *c.* 1900

The parish of Clewer covered a wide area and at one time the village was quite separate from Windsor. The Sisters of Mercy had a convent in Hatch Lane and associated with it was a large hospital. This later passed into local authority control and became a home for the elderly. Rebuilt in the 1950s and again in 2005 as Queen's Court, it still serves this purpose today.

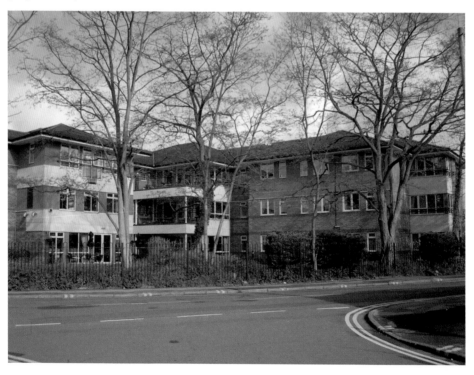

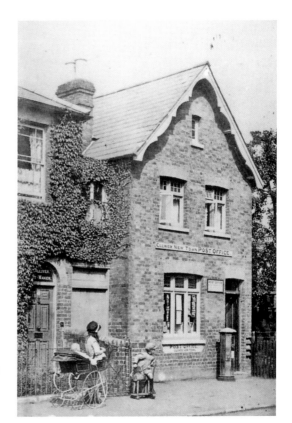

Clewer Post Office, *c.* 1890

Two interesting survivors of the village of Clewer are the post office of 1886 and the police station. At one time the post office operated independently and even had its own postmark. In this picture, taken in the 1890s, two young children wait outside, possibly while their mother transacts business within. Since then, the small building has had many uses and is currently occupied by a hairdresser's known as Capone's.

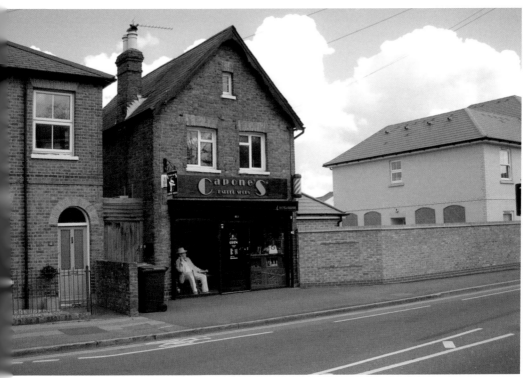

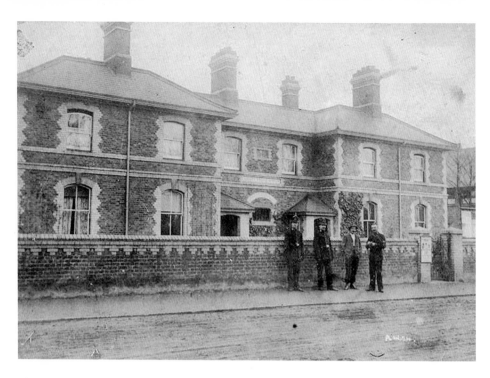

Clewer Police Station, *c.* 1890

The building known as the Colonnade was opened in 1879 and housed the police station, a role it served until 1907 when the new station opened in St Leonard's Road. It has since been home to a variety of shops, including a popular local butcher who used the cells as a cold store until closure in 2008. Today a Thai supermarket occupies this shop, alongside a convenience store, a hairdresser's and an estate agent's.

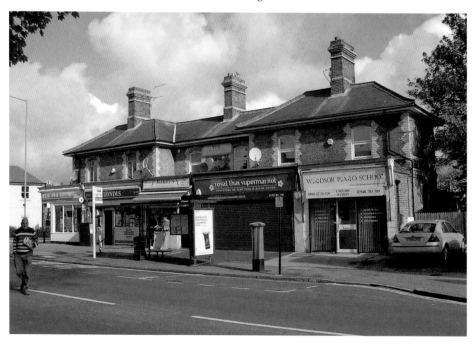

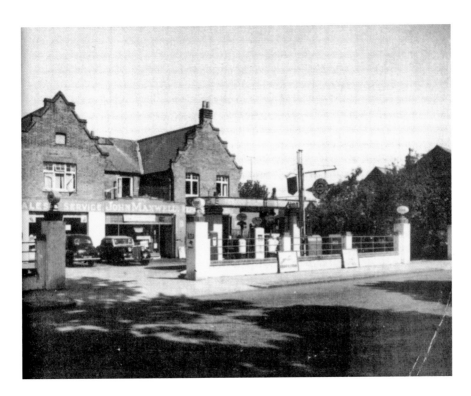

Maxwell's Garage, 1920s

As motoring developed in the 1920s, dedicated filling stations were established. Prior to that, petrol was sold by chemists. Maxwell's garage opened in 1919 adjacent to the police station, in the building previously occupied by St Augustine's Boys' Home, and did a brisk trade with traffic going out to Dedworth. A modern Shell station and a car leasing company now trade on the site.

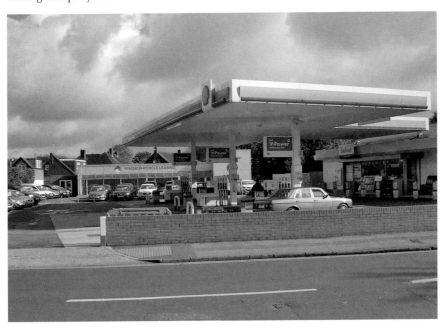

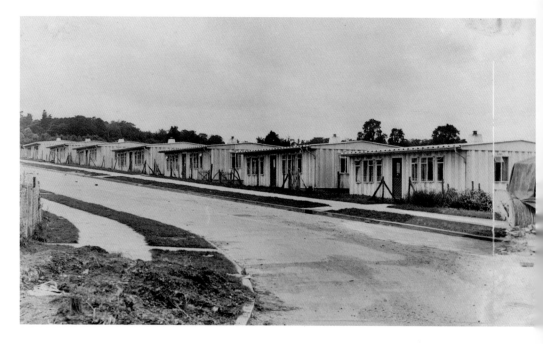

Foster Avenue Prefabs, 1970s

Dedworth was a small village to the west of Windsor until the First World War. Following this, considerable development took place as slum areas in the town were cleared. After the Second World War, the acute housing shortage was solved by the erection of prefabs by German prisoners of war. In the 1970s, they were replaced by an attractive development of council houses and Osgood Park – named after the Chelsea and England footballer who was brought up in the area.

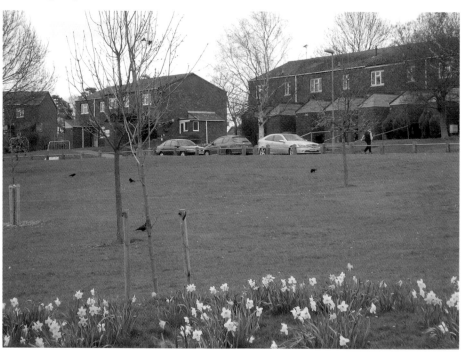

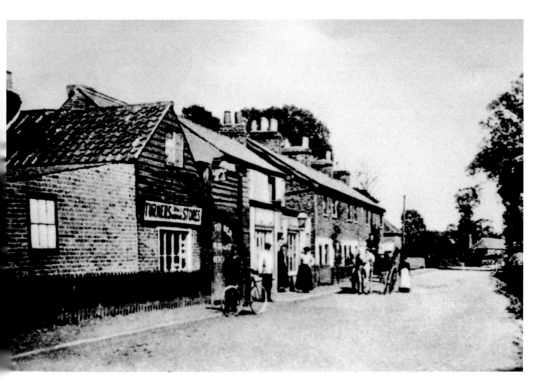

The Queen Public House, Dedworth, 1905

Although Dedworth is now the main residential area of Windsor, after it was greatly developed in the 1960s and '70s, a few reminders of the old village remain. An example is the Queen public house. Since 1905, the road has been raised and widened, and nearby houses have gone and new ones built, but the pub remains substantially as it was – externally at least.

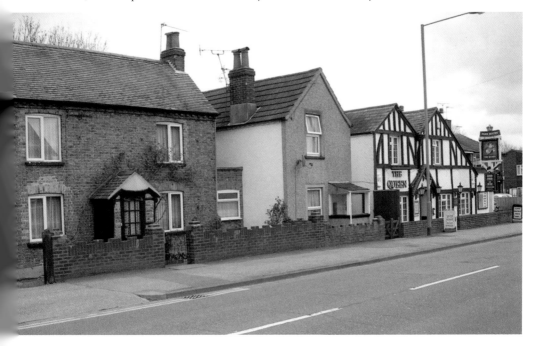

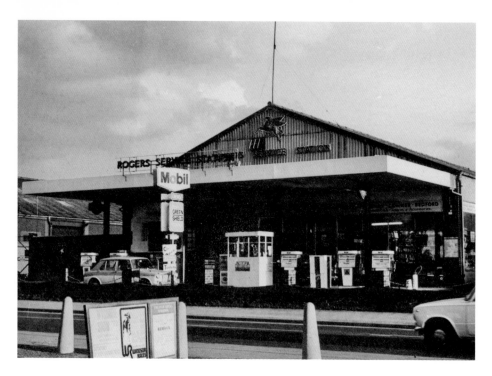

Rogers Garage, 1970s

The Rogers family owned a large amount of land in Dedworth, and in the 1930s opened a garage and filling station along the road to Twyford. The business was gradually run down in the 1990s and the land then sold to Tesco, which opened a superstore on the site serving the whole of the Windsor area and beyond.

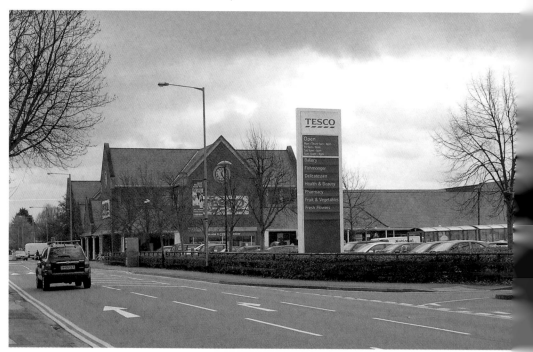

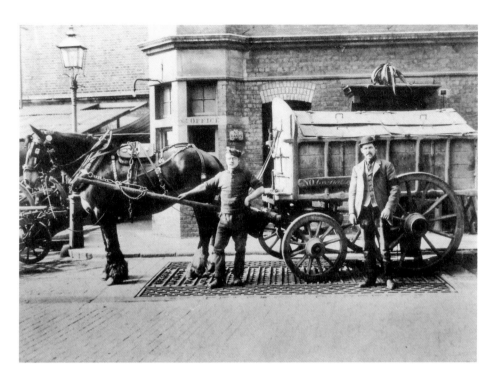

Refuse Collection, 1890s

The collection of household rubbish has been the responsibility of the council for many years. In 1895 1hp carts sufficed. An example is shown here in the Love Lane depot in central Windsor. Today, operations are based in Dedworth and contractors use a fleet of sophisticated recycling vehicles to collect the refuse.

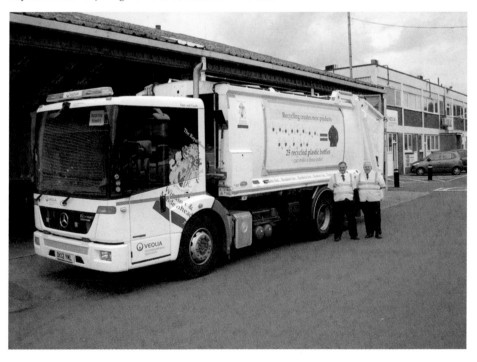

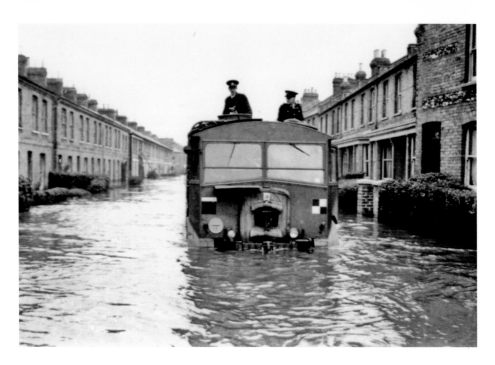

Arthur Road, 1947

Much of Windsor's nineteenth-century development was near the railway, and the houses along Arthur Road are typical of that time. The 1950s Development Plan envisaged the clearance of Victorian housing stock to allow for a dual carriageway. The plan was never completed and most of the houses survived. During the 1947 floods, the Army was called in to assist the police. Over sixty years later it is the parked cars, not water, which impede the traffic flow.

Sydney Camm's Former Workshop, 1960, and Hurricane Replica, 2011

Sydney Camm was chief designer for the Hawker Aircraft Company from 1924 to 1966. He acquired his skills from his father, a joiner, and at the Royal Free School. In 1910 he was a founder member of the Windsor Model Aircraft Club based in this Arthur Road workshop, shown just before demolition. The Hurricane fighter, successful in the Second World War, was of Camm's design. A plaque in Ward Royal records the fact. The replica plane was erected in Alexandra Gardens in 2011.

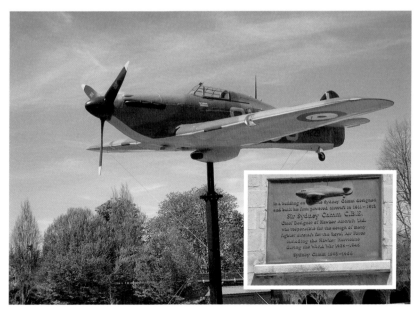

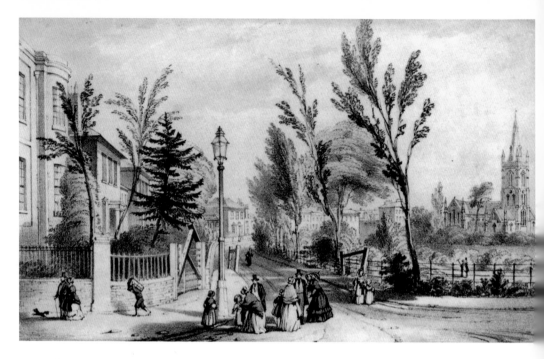

Clarence Crescent, 1830

As the town became more affluent in the early nineteenth century there was a demand for quality housing. In the 1830s, when New Road (later to become Clarence Road) was laid out, James Bedborough, a local builder and sometime mayor, erected some grand houses in what became known as Clarence Crescent. The street remains exclusive today, although Ward Royal looms behind. The view of Holy Trinity church has long been obscured.

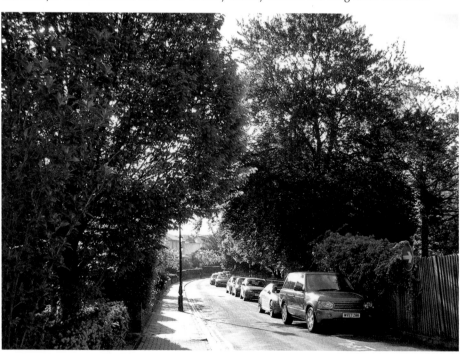

Princess Christian Nursing Home, 1950s
Clarence Villas, on the corner of Clarence Road and Trinity Place, was converted into the Princess
Christian Nursing home in 1904. It remained an exclusive private hospital until closure in 2005.
Mrs Thatcher was a patient here in the 1980s. It is currently being converted into apartments but
the economic downturn has brought this to a temporary halt.

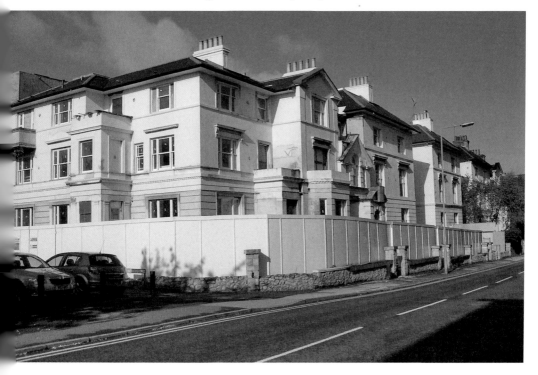

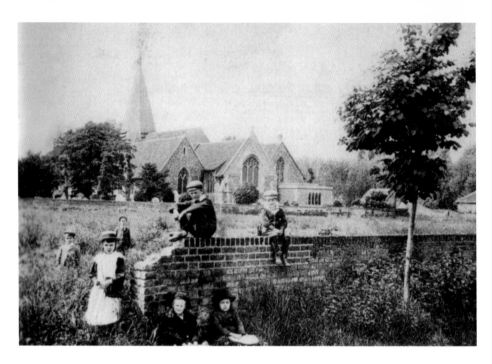

St Andrew's Church Clewer, 1880s

The parish of Clewer predates the Norman Conquest and St Andrew's church, built in 1080, is the oldest surviving building in the area. The rural scene from over a century ago shows spacious fields and places for young children to amuse themselves. Today the church is surrounded by roads and houses, but still ministers to the local population, and on a winter's evening can be very atmospheric. Sir Daniel Gooch, of GWR fame, is buried in the churchyard.

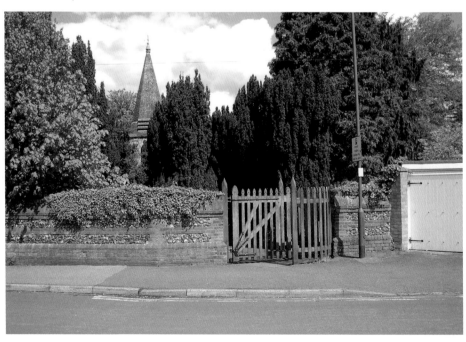

Windsor, St. Stephen's College and Church.

St Stephen's Church, 1905

St Stephen's church was built in 1872 to cater for a growing number of worshippers in the Vansittart Road area. A single car negotiates the turn from Oxford Road in 1905. Today the church stands among a sea of parked vehicles. The Princess Margaret Rose School was situated nearby. Interesting Victorian survivals are the cast-iron gullies that carry rainwater across the pavement to the gutters in the surrounding roads.

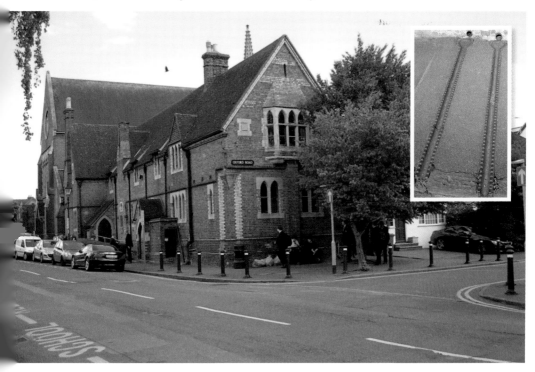

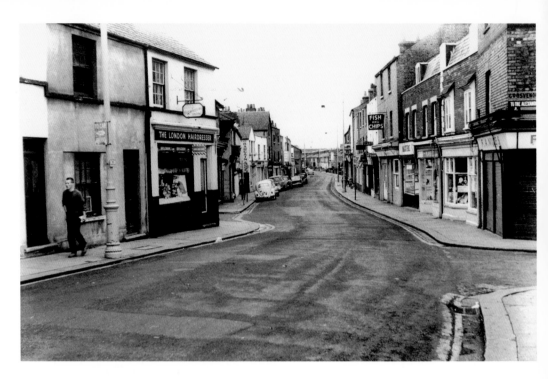

Oxford Road, 1960, and Ward Royal, 2013

Originally the route to Maidenhead, Oxford Road was the centre of a maze of Victorian streets in the Goswell area. These were cleared in the 1960s and replaced by the brutal Ward Royal complex, changing this part of Windsor completely. The two ends of the road and some of the original housing have survived, and are now designated a conservation area, while Ward Royal provides much needed accommodation near the centre of town.

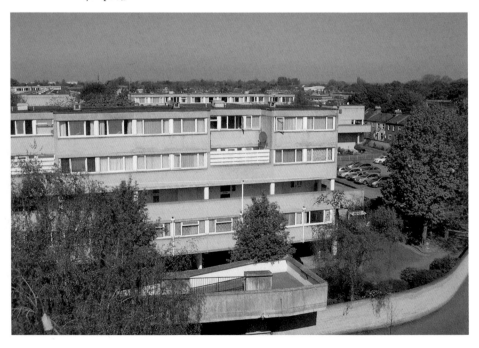

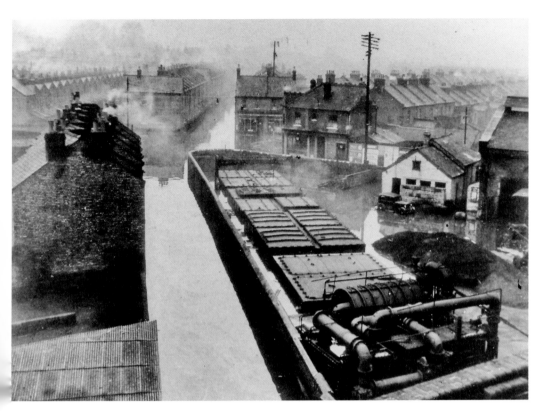

Goswell Road, 1947

The Goswells also housed the gasworks, which was supplied with coal by a special siding from the goods yard. The transition has been total. The 1947 picture, taken from the railway viaduct, shows the area under water and could be a view of a grim industrial town. In the modern view, two large buildings, Windsor Travelodge and Windsor Dials Office development, dwarf the surroundings, with Goswell Road passing between them. King Edward Court shopping centre is in the background.

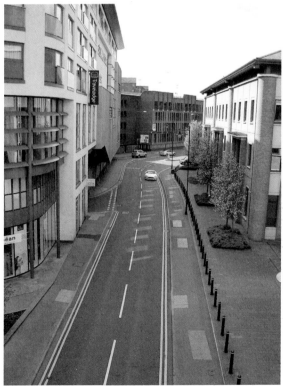

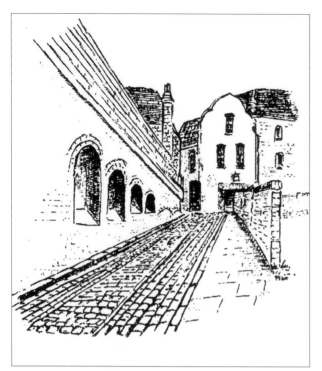

Goswell Hill

When the railway came to Windsor, a narrow road was built alongside the viaduct to allow vehicles to reach the upper town. Known as Goswell Hill, it has survived the great changes that have taken place, even retaining the granite sets, which enabled horses to get a grip while climbing. It is easy to see how it gained the local name of 'Breakneck Alley'. Today, there is no through traffic but the railway arches accommodate a number of nightclubs.

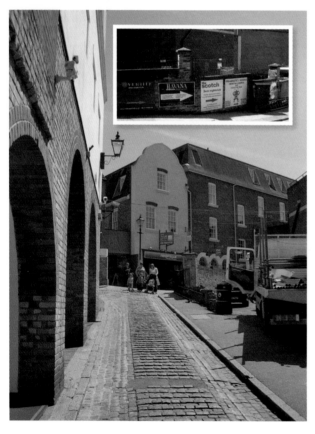

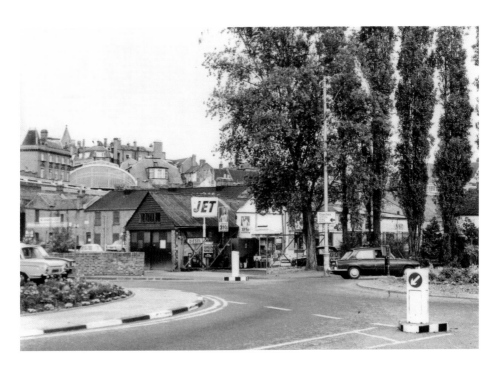

Arthur Road Roundabout, 1960s

By the 1960s the Goswell area was run down and in need of redevelopment. This came a few years later as the modern view shows. King Edward Court shopping centre was followed by Windsor Dials, seen here from the front, and finally the Travelodge. On the site of Windsor Dials stood the Noah's Ark public house, the last to retain a Burges Brewery plaque now incorporated into the end wall of the final house in Arthur Road.

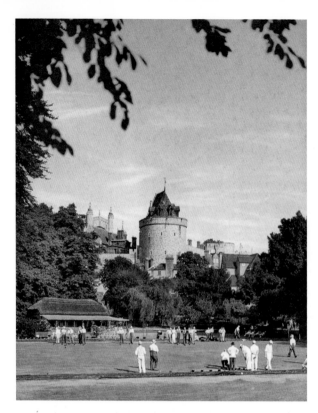

Bowling Green, 1949 & 2008
Goswell Meadow was bought by the National Trust in 1910 to ensure an uninterrupted view of the castle from the river. It was leased to the Windsor and Eton Bowling Club in 1922. Little has changed over the years, although in 2012 the Jubilee Fountain was built on the adjoining land. The ground is one of the finest pieces of greensward in the town and, when matches are in progress, spectators are treated to a sylvan English scene.

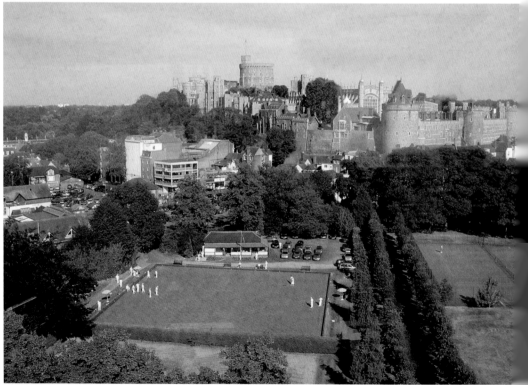

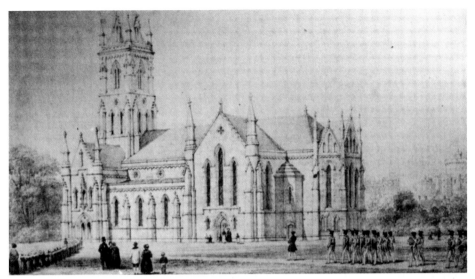

Holy Trinity, 1843
Holy Trinity church dates from 1844 and serves as the Garrison church. The print of Clarence Crescent shows it in the distance. The modern picture was captured one spring morning as the sun was directly behind the spire. For many years the council paid for the clock to be maintained, and generations of students at nearby East Berks College have marked the passage of time in lectures as it beats out the quarters.

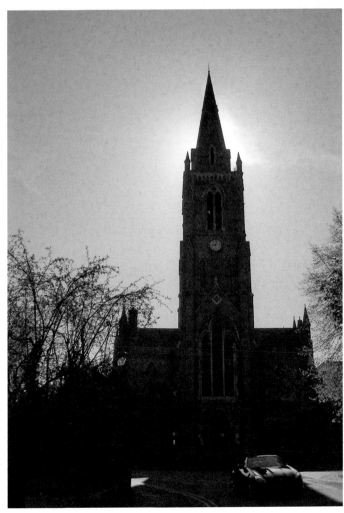

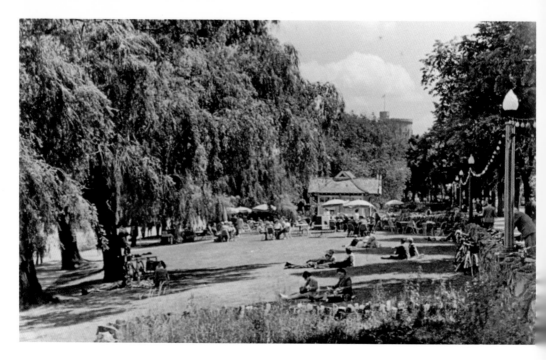

Riverside Relaxation, 1950s

The river has always drawn people to its banks, as shown by the 1950s view. Across the road the attractive Alexandra Gardens were laid out in 1902. For years, a bandstand provided entertainment but this has been superseded by a children's playground, crazy golf and, in winter, an ice rink. The gardens remain well tended, providing a venue for a variety of public events during the summer, and a place to relax and sunbathe away from the bustle of the town.

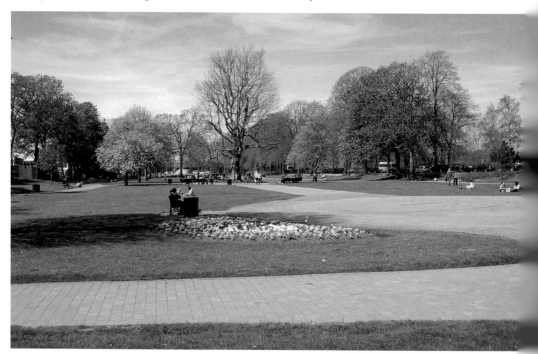

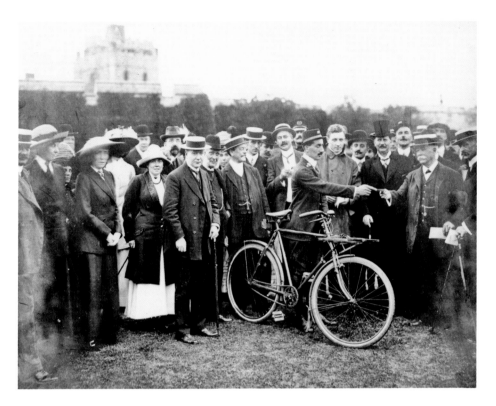

Aerial Post, 1911

Windsor received the first ever UK airmail in 1911, when a plane piloted by Gustav Hamel brought post from Hendon to mark the coronation of George V. The plane landed in a field near the castle, the mailbags were collected by bicycle, sorted, and put on the London train. In 2011, the scene was recreated by staff and The Friends of the Windsor & Royal Borough Museum. An original airmail postbox is on display at the museum in the Guildhall.

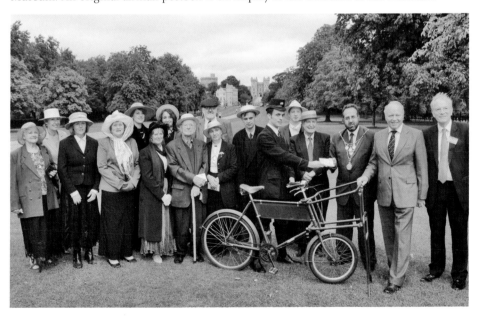

Royal Windsor Racecourse, 1928

Horse racing has been a popular sport in Windsor since the sixteenth century. There were several racecourses in the area at one time, with Ascot being the most famous. Windsor's figure-of-eight course was laid out by John Frail on Rays Island in 1866 and continues to attract the crowds to its Monday evening meetings during the flat racing season. In the early days it was not uncommon for jockeys to fall into the river, but improvements make this unlikely today!

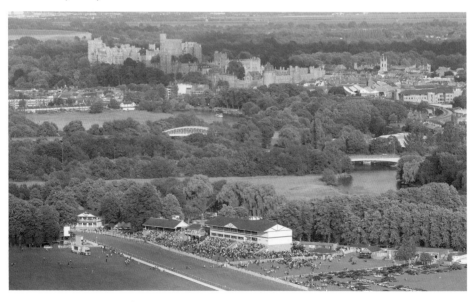

Acknowledgements

Many of the early pictures in this book are in the Royal Borough Collection, to which we have had free access, or from Beryl Hedges' private collection. Other images have been kindly supplied by Windsor United Reformed church, Rob Gordon and Damon Clarke of the Windsor and Eton Bowling Club, Kevin Mc Cormack of the Online Transport Archive for the picture by the late Marcus Eavis, Daphne Fido and Windsor Royal Racecourse. Other photographs are from the Francis Frith Collection, Leicestershire, Leicester and Rutland Record Office, the Science and Society Picture Library, Picture from Above, Mike Swift Photography and the John Lewis Archive, all of whom granted permission to use copyrighted material. Picture 7A was provided by the Royal Collection Trust/copyright Her Majesty Queen Elizabeth II in 2013 and 34A is copyrighted TfL from the London Transport Museum Collection.

The Army allowed us to photograph inside both Victoria and Combermere barracks.

We would like to extend our thanks to all those mentioned above and the Arts and Heritage staff of the Royal Borough of Windsor and Maidenhead. If anyone has been overlooked we must apologise.

The majority of the modern pictures were taken by Malcolm Lock during 2013.

KEN PEARCE

UXBRIDGE

THROUGH TIME

Uxbridge Through Time
Ken Pearce

This fascinating selection of photographs traces some of the many ways in which Uxbridge has changed and developed over the last century.

978 1 4456 0522 7
96 pages, full colour

Available from all good bookshops or order direct
from our website www.amberleybooks.com